G000077867

THE SOLWAY FIRTH
TO HARTLAND POINT

Mike Smylie

AMBERLEY PUBLISHING

Acknowledgements

Photographic books such as these are as much about the visual as the writing, and therefore an author assumes the greatest gratitude to those who supplied the quality photos. Although some come from my own collection, many do not and therefore I am especially indebted to Michael Craine, Pauline Oliver, Jennifer Snell, Ann Bayliss, Simon & Ann Cooper, Hugo Pettingel, Bridget Dempsey, Stephen Perham, Charlie Perham, Mike Arridge, Len Lloyd, Alun Lewis, John Owen, Jennifer Snell, Felicity Sylvester, to both the Lancaster and Manx Museums, and lastly to the other individual members of the 40+ Fishing Boat Association, whose names I cannot remember, for their contributions. Thanks also to Charlie Perham, photographer of Bristol and Clovelly, who agreed to let me use six of his finest and finally to Judith Wood for sharing her dad's old photos, a couple of which are included. Her dad was my dad's Best Man when he married my mum and so, in some strange way, it's fitting to include them.

General Note to Each Volume in This Series

Over the course of six volumes, this series will culminate in a complete picture of the fishing industry of Britain and Ireland and how it has changed over a period of 150 years or so, this time frame being constrained by the early existence of photographic evidence. Although documented evidence of fishing around the coasts of these islands stretches well back into history, other than a brief overview, it is beyond the scope of these books. Furthermore the coverage of much of today's high-tech fishing is kept to a minimum. Nevertheless, I do hope that each individual volume gives an overall picture of the fishing industry of that part of the coast.

For Ana and Otis

First published 2014

Amberley Publishing
The Hill, Stroud
Gloucestershire, GL5 4EP

www.amberley-books.com

Copyright © Mike Smylie, 2014

The right of Mike Smylie to be identified as the Author of this work has been asserted in accordance with the Copyrights, Designs and Patents Act 1988.

ISBN 978 1 4456 1453 3
E-BOOK ISBN 978 1 4456 1467 0

British Library Cataloguing in Publication Data.
A catalogue record for this book is available from the British Library.

Typeset in 9.5pt on 12pt Celeste.
Typesetting by Amberley Publishing.
Printed in the UK.

Fishing Ways

The West Coast of England and the Welsh coast have some of the best remains of fish weirs in the country, and one example in the Menai Strait has been rebuilt so that its shape and workings can be seen, even if openings in the wall allow the fish to escape – use of these structures has been prohibited by law for decades, because of their unselective but effective way of capture. From Morecambe Bay in the north, down to Minehead and Lynmouth on Exmoor coast, the outline fish weirs still can be seen upon the foreshore at low water in a mixture of bays and rocky coves.

These generally are structures positioned along the route fish tend to swim. Built usually of a low stone wall with oak posts set in, between these posts a fence is woven from hazel or willow rods that allow the water to flow through but not the fish. At low water, once the tide has receded, the fish are left in a shallow pool, from which the fishermen extract them using a dip net, usually as fast as possible to compete with the screeching seagulls overhead. In some parts, such as the Solway Firth, nets are used (as illustrated in Volume 2 of this series, *From Duncansby Head to the Solway Firth*).

Salmon was once prolific along this coast, and various techniques have traditionally been adopted for its capture. These include the haff net and the lave net, the stop net and compass net and seining with a long net.

Fishing has for centuries been important to the people of the Isle of Man (as it has for most island folk), and in 1883 it was said that one in four Manxmen depended on it either directly or indirectly for their livelihood. Herring was, for much of this time, the lifeblood of these fishers, until stocks declined in the second half of the twentieth century. It was once said that a Manx fisherman had to inform his nearest boat if he found a good shoal of fish, something fishermen seldom do today.

Good quantities of shellfish – such as cockles, mussels, scallops, shrimps and prawns, and crabs and lobsters – are found along this coast. Crabs and lobsters, however, other than a fleeting mention, will be dealt with in some detail in Volume 4 of this series.

Fishing Between the Tides: Fixed Engines

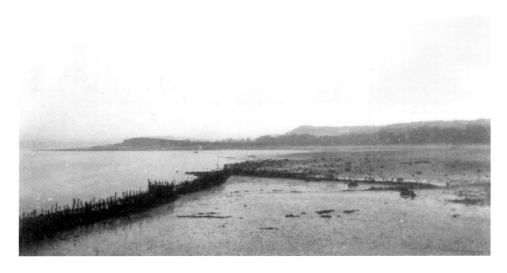

Fixed engines is an archaic term for fish weirs, nets and other man-made structures set between the tides to catch fish. In this photograph can be seen the extent of the fish weir named *gorad bach* in Welsh ('little weir'), which used to exist on the beach 2 miles east of Beaumaris on the Menai Strait. Used up to the 1960s, the weir was worked by brothers John and Wilf Girling after their grandfather obtained a lease on the weir in the 1860s. (*Bridget Dempsey*)

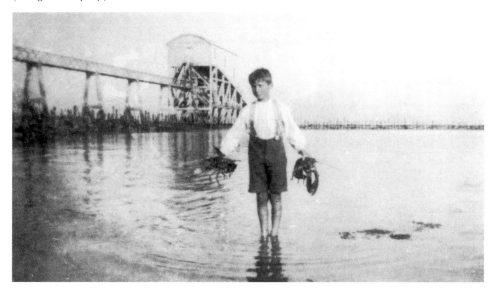

The weir was positioned alongside the deep-water Beaumaris lifeboat station on its roller slipway, and enclosed possibly an acre of the foreshore. Here a small boy proudly displays two lobsters from the weir, for these 'fixed engines' could catch fish and shellfish alike. (*Bridget Dempsey*)

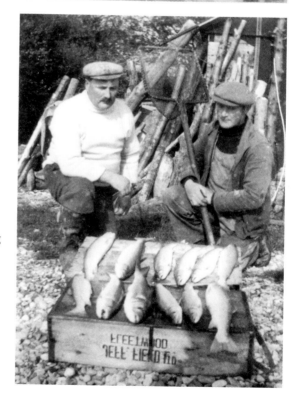

John Girling (senior) emptying the weir with a dip net that is half full of whitebait. He is standing on the low stone wall, and behind him the stout oak posts that support the woven hazel are clearly visible. The lower parts of the hazel walls are much more tightly woven, to prevent small fish escaping, while the more open wall allows the full flood (or ebb) tide to easily flow through without damaging the structure. (*Bridget Dempsey*)

Brothers Wilf and John Girling displaying their daily catch in the early 1960s. They caught mackerel, herring, whitebait, bass, salmon and all manner of weird fish, including the green-boned garfish. Sometimes the whitebait were let out of a small opening called the 'bass trap' because bass and salmon tended to linger outside waiting to devour the whitebait; they were then landed using a lap net fixed onto a pole. (*Bridget Dempsey*)

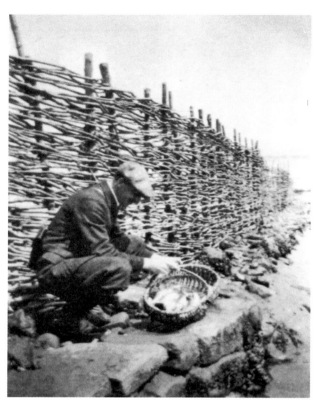

Upkeep of these structures was formidable as damage was often inflicted in a gale. Spruce sometimes replaced the oak posts and at times willow was used instead of hazel. This weir is the Plover Scar weir on the River Lune in Lancashire, where they were referred to as 'hedge baulks'. The man does look a bit too well dressed to be messing about emptying the pool left after the tide is down.

Another view of the Plover Scar weir with several well-dressed folk emptying the pool with dip nets. Again the difference in the weave of the wall is obvious. The woman looking on is hopeful! (*Lancaster City Museums*)

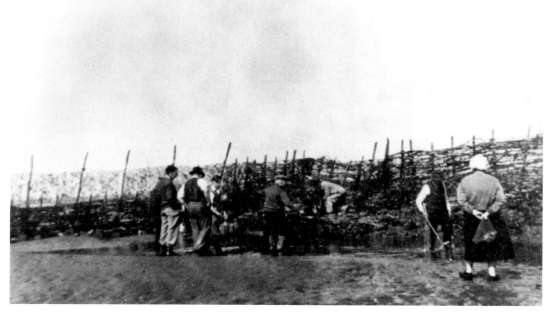

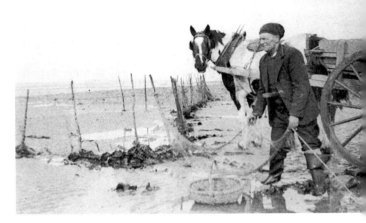

A Flookburgh fisherman tending his stake nets set out on the sands of Morecambe Bay. These were simply nets fixed to wooden stakes set into the sand. A horse and cart was the best way of carrying the catch back to the shore.

Nets set on the foreshore of Bridgwater Bay, at the mouth of the River Parrett. Today this group of nets, and others further out, are serviced by Adrian Sellick, whose family have been doing the same thing since the 1820s. The seagulls are getting excited here as Adrian begins the process of emptying any fish. Although often called 'shrimp nets', these catch all number of passing fish. On the River Ribble similar nets are called 'Hose nets', and in the River Mersey and at Cardiff they refer to them as 'Mallingers'.

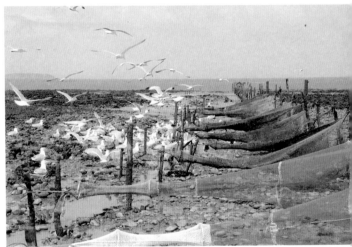

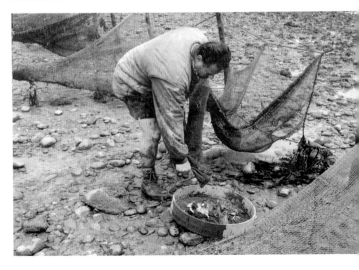

It's a tiresome process untying, emptying and retying each net when, quite often, the catch consists of a load of seaweed and a few odd tiny fish. Occasionally a net will hold a salmon, whiting, Dover sole, mullet, dogfish, or shrimp.

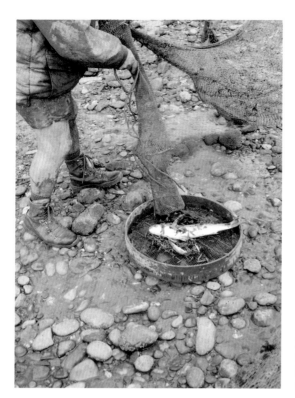

This one gave up a small bass along with quite a few shrimp.

Further out into the Bristol Channel, on the outer limits of the Stert Flats, Adrian has stake nets, which sometimes give up dabs and other flat-fish, such as skate.

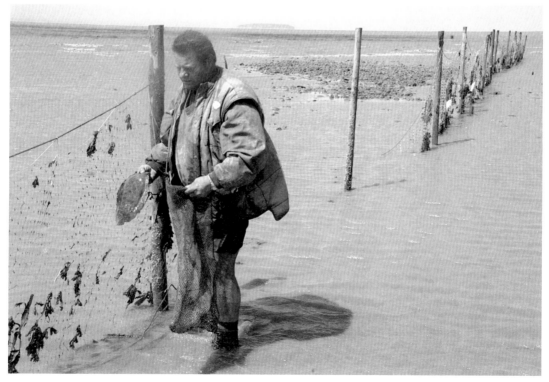

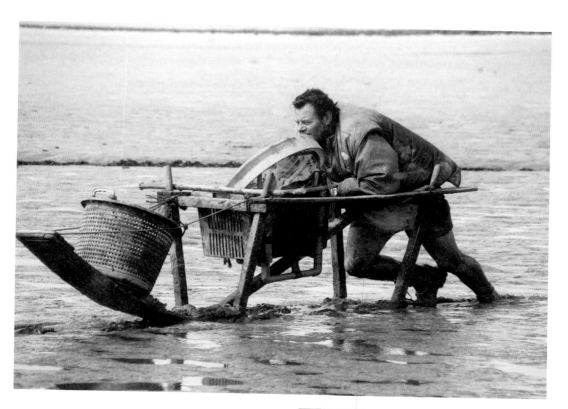

Because of the thick mud out in the bay, Adrian uses a mud-horse to carry his catch back to dry land. This wooden structure was once used in many places around Britain but today Adrian is the last of the so-called mud-horse fishermen. Adrian will push the horse through deep mud, knowing that he cannot stop until a particular spot where there is a hard layer below the mud. It's a hard life: working in all sorts of weather, having to watch the tide, which can flood in very quickly, and sometimes having nothing to show for the trouble.

Adrian's father Brendan, who worked the mud-horse for many years, is seen here working in the small shop adjacent to their house after having boiled up the shrimps from the last outing. All the catch is sold locally, either through the shop or to customers, especially local restaurants, who pre-order their fish. Sadly this mode of life is fast disappearing, and one wonders just how long the Sellicks can continue in this way.

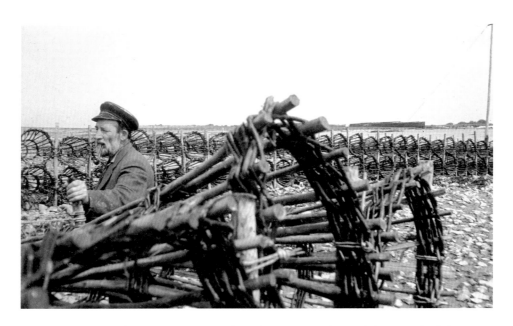

Bob Thorne had stake nets at the 'Hang', on the opposite shore of the mouth of the River Parrett. Here he is with his putchers on Black Rock, a bit further upstream of the Parrett. Putchers were conical baskets, about 6 feet long and made from willow; they were stacked in ranks up to six high, although these are only two high. Butts – or putts – were much larger, but similarly shaped and made in three parts from willow; the mouth is the kype at about 6 feet in diameter, the butt is the middle part, and the forewheel is the end in which any fish end up. The whole structure could be 15 feet in length.

Bob Thorne's fishing hut on the River Parrett with two of his flatner boats alongside. This hut has recently been sold and the new owner intends to restore it to its original condition.

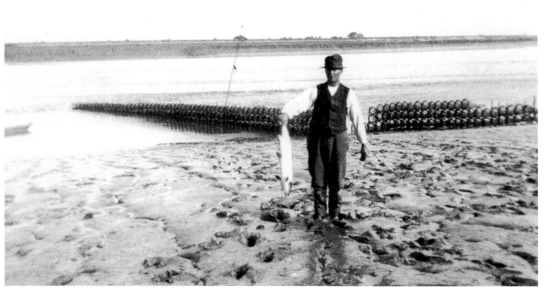

A fisherman with a salmon from a rank of putchers on the River Severn. During the closed season the putchers were taken ashore and the forewheel removed on the butts so that fish could swim straight through.

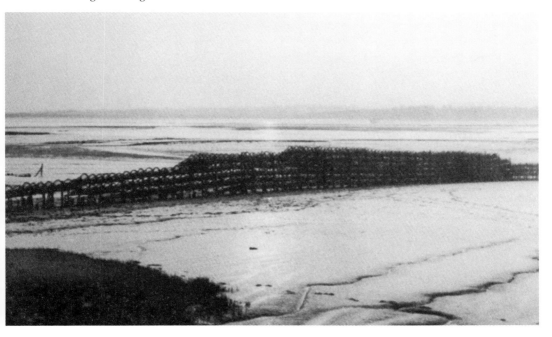

A huge rank of putchers on the River Severn, where the maximum height in the middle allowed for seven putchers. These structures were deadly in catching salmon, so their use was curtailed in the twentieth century. Today a couple of ranks still exist on the river, although nowadays they are made from a steel framework with steel baskets.

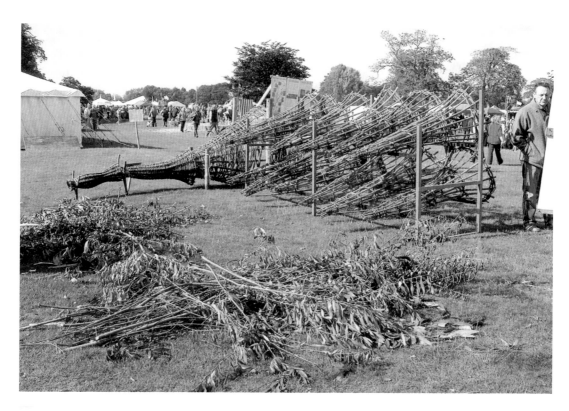

A putt and a small rank of putchers on display at the Frampton Country Fair in 2012. The difference in the size and construction of the weirs is clearly visible.

These putchers are the work of fishermen Derek Riddle and Don Huby, who have worked the River Severn most of their life and each year display at Frampton.

Shellfish: Mussels & Cockles

Cockles are found in numerous sandy bays and river estuaries along the West Coast, especially in the Solway Firth, Morecambe Bay, the rivers Ribble and Dee, along parts of the Menai Strait and in the Burry Inlet.

Here a group of women are seen gathering cockles on the Llanrhidan Sands, on the south side of the Burry Inlet in about 1920. Hand-picking was a back-breaking job which involved raking the sands with a *cramm* – a small seven-pronged rake – to uncover the cockles, which were then hand-picked. Here the pickers were almost exclusively women and there were some 250 of them around this time, all from the local villages, such as Penclawdd, Crofty, Llanmorlais, Gowerton and Loughor.

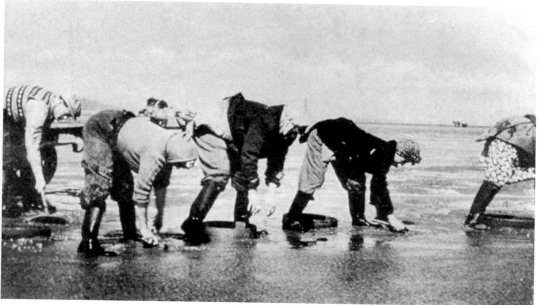

Picking was often a family affair. Here a man and woman (possibly man and wife) are out on the sands of Morecambe Bay. The wooden implement the woman is holding is a *jumbo*, a wooden platform attached to handles, which was rocked on the sand to create suction and thus bring the cockles to the surface. Although still used in and around the northern cockle grounds, in South Wales their use is banned.

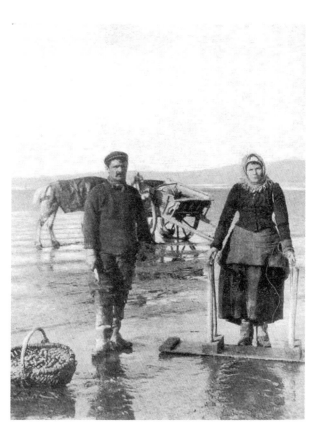

Here the horse is feeding from the upturned cart while its owners go on with the laborious task of collecting the cockles. A horse and cart was the only method of carrying the bags of cockles back to shore. However, as was seen with the deaths of the Chinese pickers in 2004, the tide moves in swiftly over these sands, and pickers have to be constantly alert to this threat.

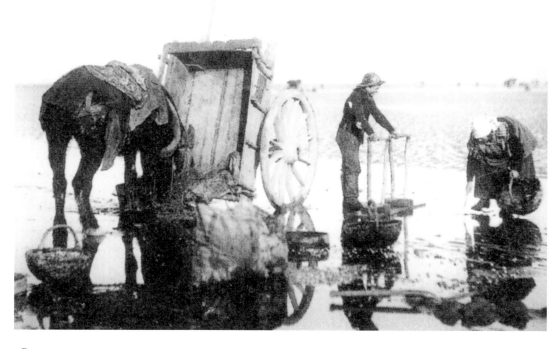

Cockling is carried on with great gusto in many parts and, until recently, the pickers were largely unchecked. Here a picker is transferring this catch from a bucket into a hessian sack, in which quantity they are sold. The fishing areas are closely controlled by the local fishery committees, who decide which areas are open for picking and which remain closed, depending on advice from scientists.

Mussels are also collected in Morecambe Bay, the Conwy river estuary, the Menai Strait and in the estuary of the rivers Taw and Torridge. At Conwy they were traditionally either hand-picked from rocks and pools at low water or raked up from the seabed using a rake with a net attached, such as the one photographed here. The latter method was considered less destructive to the mussel beds.

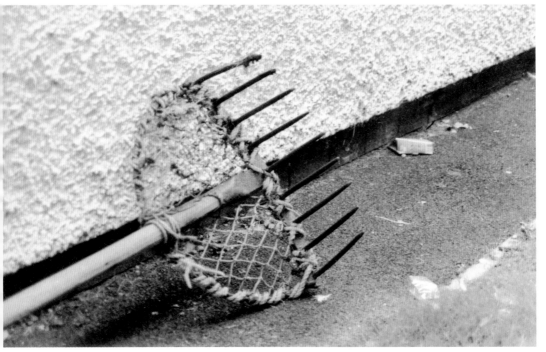

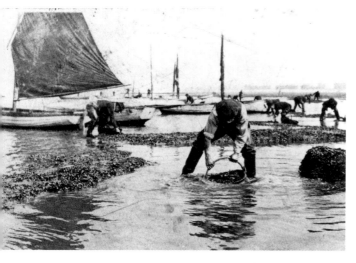

In Morecambe the mussels were hand-picked in shallow water over the skeers, and here they are being washed in the seawater. The basket was called a *tiernal*. Today, however, mussels have to undergo treatment, which involves them being placed in tanks where they are left for forty-two hours under ultraviolet light to kill off any bacteria. Afterwards they are washed, riddled, scrubbed and bagged before being sent to market. (Lancaster City Museums)

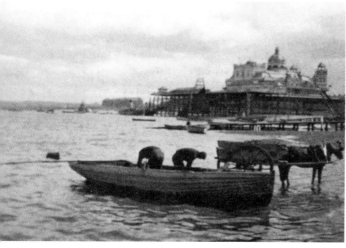

Under the shadow of Morecambe pier, a mussel boat is being unloaded while the horse and cart stands patiently waiting. Many of the small boats used for musselling, built locally at Arnside or Overton, were adapted for taking trippers out in the summer.

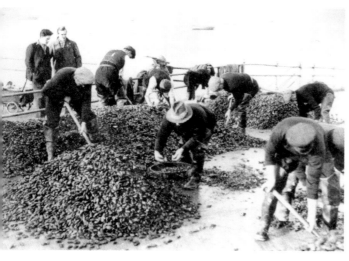

The mussels were piled up on Morecambe's promenade, where visitors were able to watch the fishermen sort and bag them. However the council later prohibited this practice.

Mussels being riddled and bagged on the promenade at Morecambe, alongside the Calton Landing Stage Company's hut at the top of Lord Street, Morecambe.

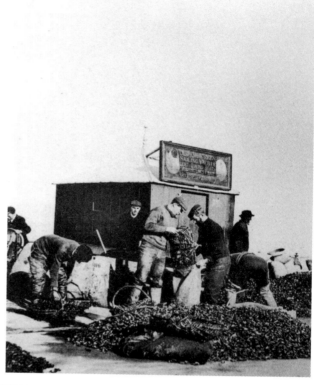

Today the vast majority of mussels – other than those farmed – are dredged from large boats. Here the dredges are being lowered from the dredger *Mytilus*. Owned at the time by Myti Mussels of Port Penrhyn, Bangor, North Wales, the dredger is capable of setting four dredges, two each side, and carrying upwards of 100 tons. Often they dredge for mussel spat, which is then seeded in particular parts of the seabed.

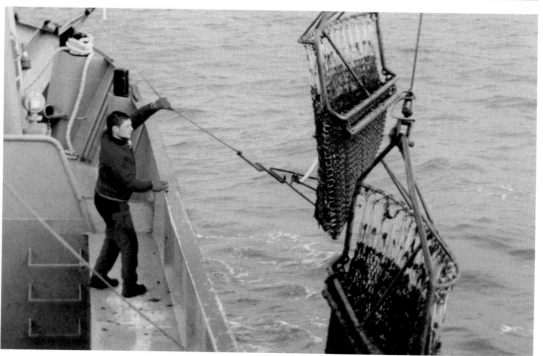

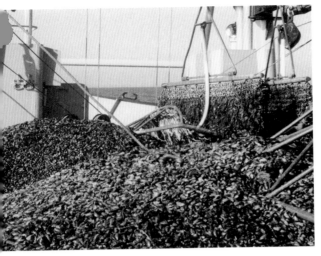

A load of mussels. Once, pearls were sought after. Halliwell, travelling in North Wales in 1860, wrote of Conwy, 'The mussels are found in considerable abundance at low water all along the shore at the entrance to the river, and are dredged by boatmen along the course of the river, as well as collected on the mussel banks. I tried my fortune with a dozen of them, a number which yielded nearly a dozen pearls, two of these the size of a pin's head; the others were exceedingly minute.' 160 ounces were said to have been collected per week in the late nineteenth century and these fetched 2s 6d per ounce.

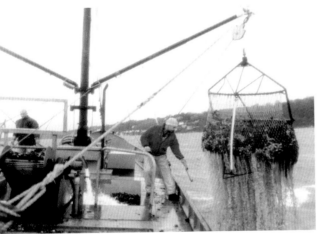

A dredge being hauled in aboard the 1905-built dredger *Tannie Christina*, BS98. Built in Holland as a general-purpose cargo boat operating between, mainly, Rotterdam and Utrecht, she was lengthened by some 6.5 metres in 1947 to 26.3 metres. Each dredge brings up about a ton of mussels and other detritus from the seabed.

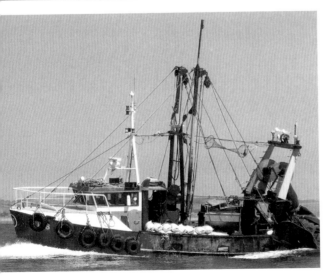

A typical scallop dredger, the 1998-built *Sarah Lena*, CT18, built as a dual-purpose scalloper/trawler. Today dredging scallops is big business although this is a relatively new fishery in terms of size. Before the mid-1970s the fishery was of a negligible size in England and Wales, and much of what was caught was used as bait. However, there followed a huge increase in landings, as first overseas markets developed and then a home market. The species is the commercial queen scallop, often known as the 'queenie'. (*Mike Craine*)

A typical beam trawl built on a stout length of hazel. Skids are fixed to either end and the net is suspended from the hazel with the bottom of the net running along the sand.

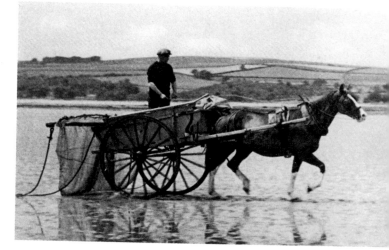

Harold Manning of Main Street, Flookburgh, the last fisherman to use a horse and cart for shrimping. He is seen here fully equipped for the sands in 1952. (*Jennifer Snell*)

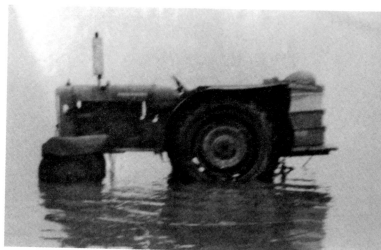

In the 1950s, tractors took the place of horses. Here is a typical tractor, modified for work in the water, with boxes of shrimps on the rear. Tractors were capable of towing two trawls of a bigger size, thus maximising the catch. For a while this was 'grand' until catches declined and eventually the number of fishermen gradually decreased.

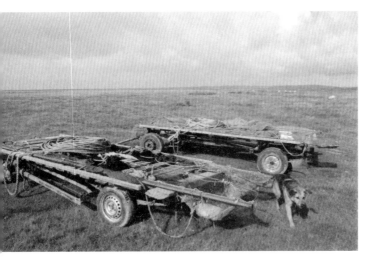

Some fishing does continue today; these trailers were photographed on the marsh at Flookburgh in 2009. Most are home-made but are still towed by tractor. Morecambe Bay shrimps continue to be marketed throughout the country.

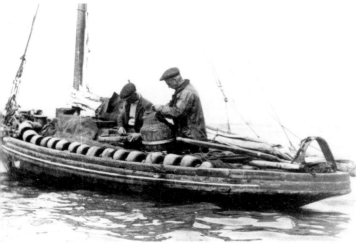

Trawls were also set behind local boats. These nobbies, as they were called, had boilers aboard so that the catch could be boiled up at sea immediately after the trawl was emptied. The end of the trawl can be seen on the deck, as can the bobbins fixed to the bottom of the net's mouth. It appears that the catch is being sorted here prior to boiling. It's worth noting that these boats also caught prawns, though the larger versions tended to work prawn trawls in deeper water. (*Lancaster City Museums*)

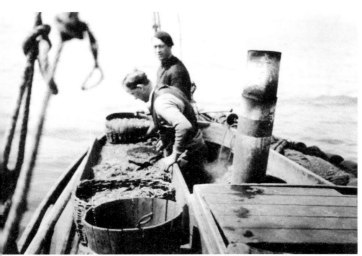

Here is another view of the deck of a nobby, with the fishermen sorting through the catch; Jack Mount is the fisherman behind. The chimney belongs to the boiler and the net can be seen neatly furled on the port side of the boat.

Ted Gerrard holds the trawl rope aboard the nobby *Hearts of Oak* in the 1970s. We will learn more of this boat in a subsequent chapter. However, it is obvious that the boat is now working under engine alone and the sails have been abandoned. The narrow cockpit of the nobbies was characteristic of their design.

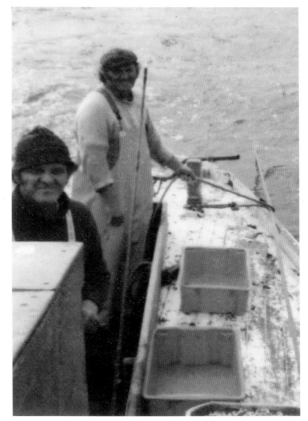

Not all boats boiled their catch at sea, and here shrimp pickers are at work in 1926. Once the catch was boiled, the tedious task of removing the shell was often regarded as women's work. It is thought this photograph was taken at Morecambe as there was no organised picking at Flookburgh, although occasionally no more than six people gathered in one house. (*Keith Willacy*)

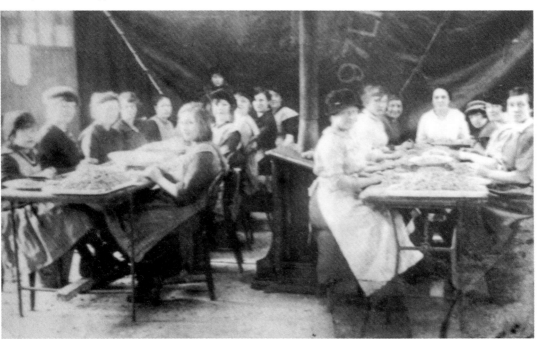

Salmon & Eel Fishing

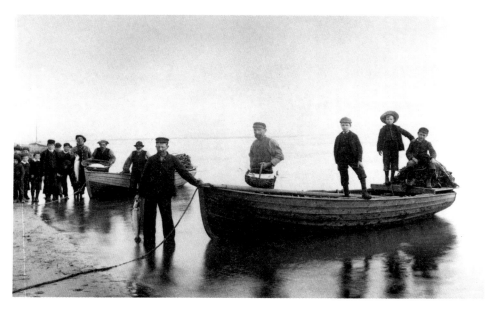

A group of fishermen on the River Dyfi estuary with two seine-net boats. The net is stored on the transom platform ready to shoot. A group of children, dressed in their Sunday best, pose for the camera, along with fishermen with salmon and bass. (*National Library of Wales*)

Salmon-netting in the Sprat Pool in the middle of the River Taw estuary. This required using a hemp net with cork floats and a lead-weighted footrope. (*North Devon Maritime Museum*)

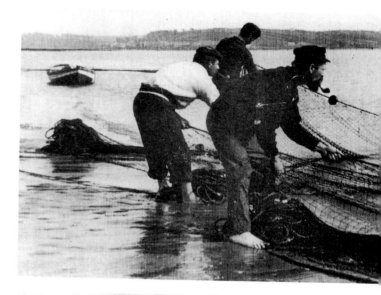

Hauling in one of the hemp salmon nets at Old Walls on the Braunton side of the River Taw estuary. (*North Devon Maritime Museum*)

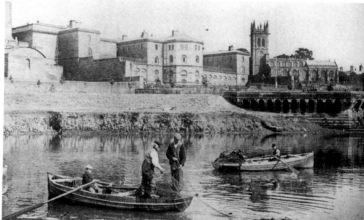

Fishermen on the River Dee at Chester shooting a seine-net across the river. Here they have a boy rowing while two men shoot – which might imply that the picture is posed. Only one man is needed to shoot the net while the other fisherman would row. Again the net is held on a stern platform.

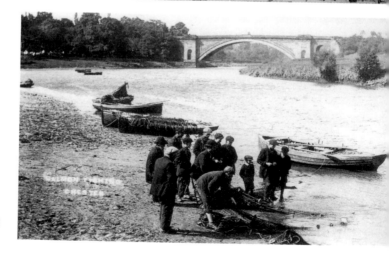

A group of fishermen at Chester hauling in their net, though there appear to be no fish in it. Seven boats are in the picture, which shows how much fishing was taking place in the River Dee.

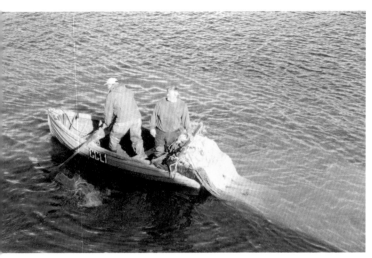

Three views of seine-netting at Porthmadog in around 2000. The first shows the net being shot from the small punt, the second the net being hauled and the third the net being fed back into the boat. There were no fish in this draught!

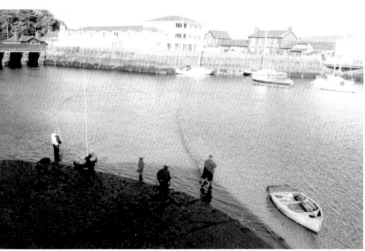

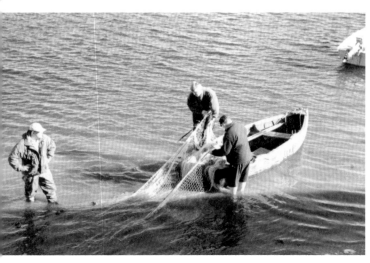

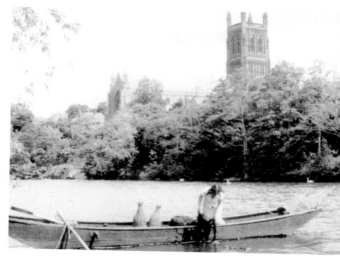

Anne Cooper, in her and her husband Simon's long-net punt, hauling in a salmon net under the shadow of Gloucester Cathedral. The punt was built locally; the couple saved it from rotting away and rebuilt it. It survives today under their ownership. (*Simon & Ann Cooper*)

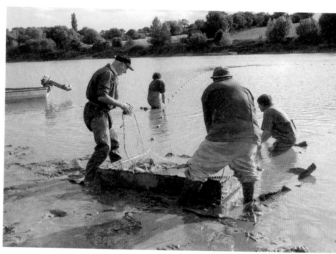

Hauling in a long net on the River Severn in around 2004. Simon Cooper is on the right. This draught produced one salmon, the only fish we caught that day! Long nets were seine nets that were used in the River Severn from above Awre. (*Simon & Ann Cooper*)

On the lower reaches of the River Severn, where the river is wider and more exposed to the wind and sea, the stop net was the method of salmon fishing. This involves anchoring a boat across the current and using a net suspended from an A-frame that is swung over the side of the boat. Three boats are moored to a chain (actually a wire, run from a stake on the riverbank to an anchor in deep water) with their nets down. (*Environment Agency*)

The stop-net boats were stout craft built to withstand the ardour of working beam-on to the tide and wind, given the extreme tidal differences in the Bristol Channel. Each boat was numbered and licensed, and up to six boats could work a chain. In Wellhouse Bay, chains were fixed at Haywards Rock, Long Ledge (2), Round Rock, Fish House, Old Dunns and The Flood. The fishery was leased to the Morse family from 1878 until fishing stopped in 1986.

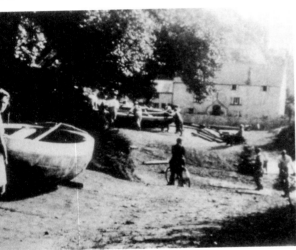

The Morse family lived at Gatcombe, a tiny hamlet on the north side of the River Severn. Here, the boats are being moved from the river into their winter positions at the bottom end of the hamlet, close to the archway under the railway from which they are manhandled. After the boats had been placed, the fishermen all used to go the Morse house to celebrate the end of the season and the salmon harvest with a meal of cold salt-beef, beetroot and mashed potato, followed by home-made apple pie, all washed down with home-made cider and stories that rolled on and on ... Three of the boats still survive although they are past any pretence of being rebuilt. (*Ann Bayliss*)

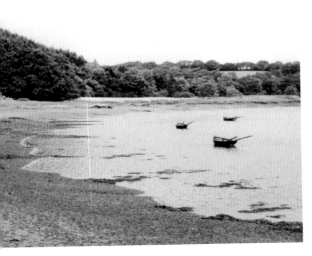

In the upper reaches of the River Cleddau in south-west Wales, a similar method of fishery was introduced, albeit on a smaller scale. Said to have been brought to the area by two men from the Forest of Dean – Messrs Ormond and Edwards – after they came to work in a local quarry, it too consists of a net suspended from two larch poles forming a 'V'. Called a compass net, it is basically a smaller version of the stop net. Here three boats – called compass-net boats – are moored on the river below the small village of Hook, where many of the fishermen came from. The method is still practised by a small band of fishermen, though only one – Alun Lewis – uses a true compass-net boat, as we shall see in a subsequent chapter.

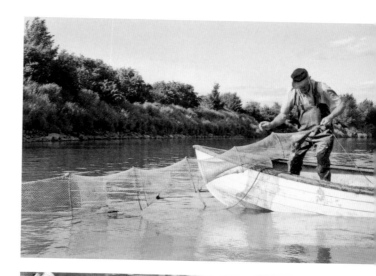

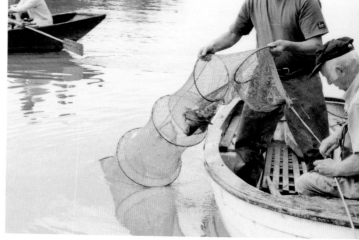

Two views of hauling in an eel set net. This trap consists of a long, small-meshed conical net supported by rings or semicircles. The net tapers to quite a small opening, which leads to a funnel at the end into which the eel swims but cannot escape.

Last of all, it's worth mentioning that dogs were used in parts of Somerset (here at Kilve) to catch conger eels. Called 'glatting', a glatting stick is used to poke the eels, which are then pulled out by the dogs. Congers have a strong grip, and one story tells of a man whose hand was stuck in the mouth of a conger that refused to let go. When the tide came in (and it comes in quickly), he had to cut his own hand off. The story continues that he went to the local blacksmith's and put his stump into molten tar. Ouch!

Herring Fishing

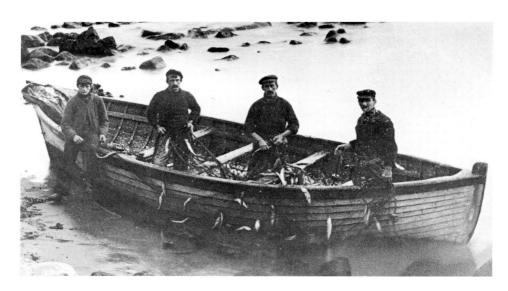

Herring fishing in Gwynedd. The north coast of the Lleyn Peninsula was renowned for the quality of its herring fishing, so that bays such as *Porth Ysgaden* (the herring port) had small beach-based boats like this one here. Herrings were taken over to Ireland in the 1700s. Porth Dinllaen and Nefyn were both known for their herring, the latter being the principle herring station on this coast. '*Penwaig Nefyn, Penwaig Nefyn, Bolia fel tafarnwyr, Cefna' fel ffarmwrs*' ('Nefyn herrings, Nefyn herrings, bellies like innkeepers, backs like farmers') was the cry of the fish wives throughout the area. (*Gwynedd Archives*)

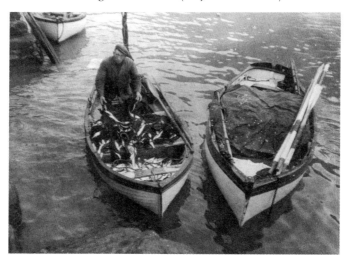

One exception is the small cliff-hanging village of Clovelly in Devon, where herring has been landed for generations. Here, Gordon Perham is pictured in his picarooner after fishing. His herrings have to be shaken from the net before being basketed ashore. The boat on the right is Si Headon's *Minnie*. (*Stephen Perham*)

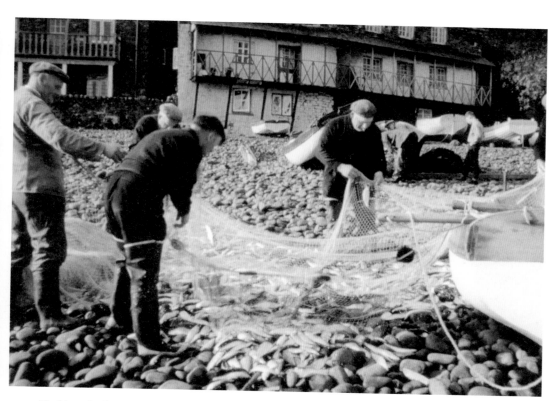

Shaking the herring out of the nets is often a job in which fishermen help others. Here at Clovelly Percy Glover, Norman, Si and Stevie Headon are clearing the nets in the 1980s. (*Stephen Perham*)

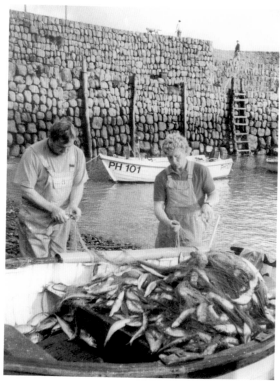

Fisherman Stephen Perham on the left is one of only a few fishermen who continue to fish for herring. Here, he, helped by Mark Gist, is sorting the catch, which often involves picking the fish from the mesh of the net, a time-consuming job. The boat is a picarooner, and today Stephen remains the only Clovelly fisherman using this type to fish, his being the newly built *Little Lily*, of which we will hear more in a later chapter. (*Stephen Perham*)

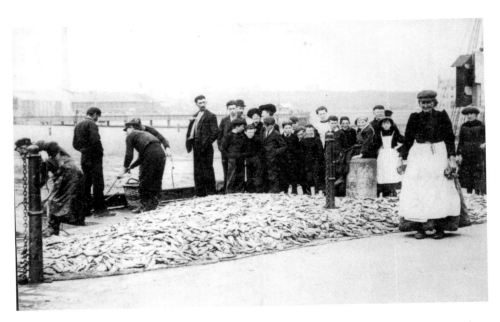

Landing herring in Ramsey, Isle of Man. Here is Mrs Kinnin on the right in the white apron; she was a well-known fish seller with a good load of herring on the quayside. (*Joe Pennington*)

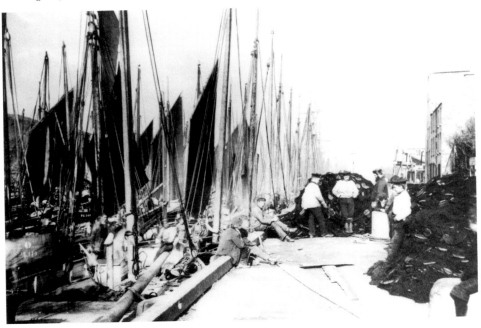

A reminder that the Isle of Man had, for centuries, a vibrant herring fishery. This survived well into the twentieth century, though by the end of that century hardly a herring was found around its coasts, even though the island was still famous for the Manx kipper. Here, fishermen are discussing the fishing among piles of drift nets on the quay at Peel around 1890, with dozens of boats moored alongside. (*Manx Museum*)

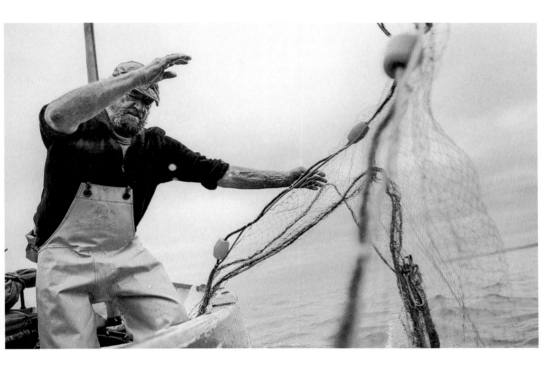

Peter Braund shooting the net. Stephen Perham, whose net it is, prefers green to the clear monofilament netting some use. He fishes only a few hundred yards off Clovelly Quay using the picarooner *Little Lily*, which he propels by sculling. (*Charlie Perham*)

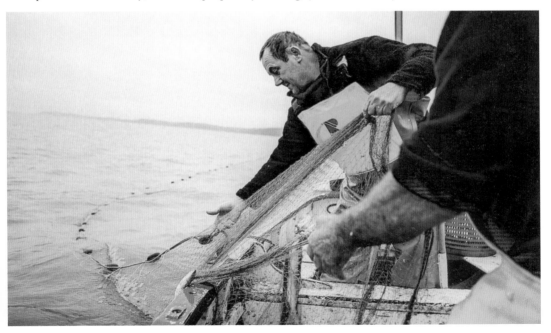

After leaving the net in the water for some time, hauling has begun. Stephen is hauling the top of the net with the floats while Peter hauls the bottom, weighted, part. (*Charlie Perham*)

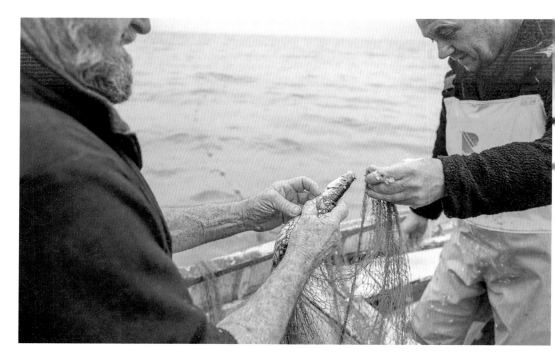

When there are not many fish in the net, they are often removed while hauling. Extricating can be a fiddly and difficult process when the net is tight around the fish. Cold hands make it even more awkward. (*Charlie Perham*)

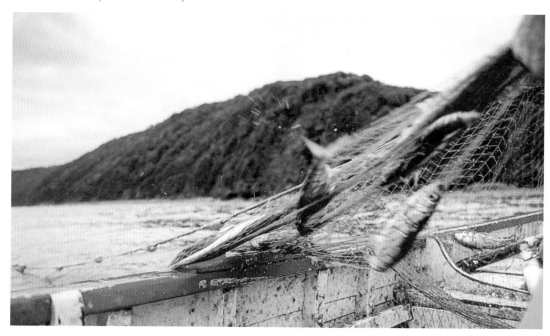

Herring begin to flop over into the boat, trapped by their gills in the net. This photograph shows how close to the shore they are working. (*Charlie Perham*)

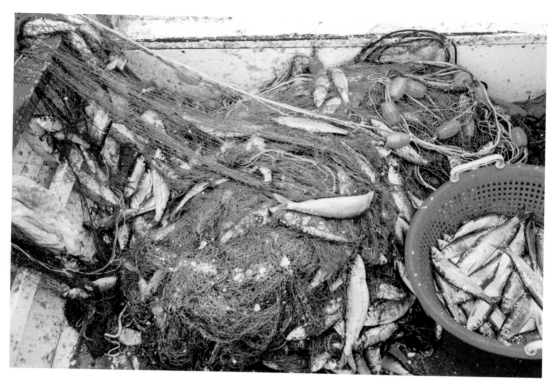

Here the fish lie in the net to be removed ashore. Those already removed have been put in the bucket. (*Charlie Perham*)

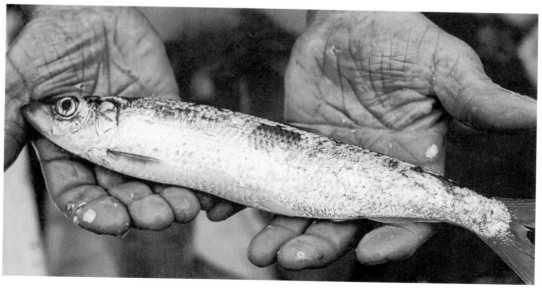

A herring in the hand is worth two... Clovelly herring are small, scaly and sweet in taste. Small herring such as these were once caught in dozens of small coastal villages dotting the West Coast. Sadly, today most do not see any herring at all, and often the houses are second homes to city folk rather than those of fishing folk. Peter's hands are almost as picturesque as the fish! (*Charlie Perham*)

Crabs and Lobsters

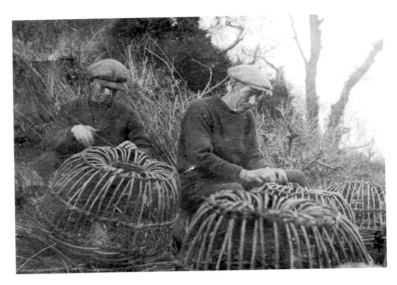

Lobster pots were made locally in many parts of the area, most notably in parts of Wales and Devon. Here, Albert Braund of Clovelly, along with a helper, is putting the finishing touches to a pot made with withies. Most these days are made from netting on a steel framework. (*Stephen Perham*)

John Olde of Clovelly showing off a lobster. Only lobsters of a minimum size across the carapace can be landed, and the smaller ones have to be placed back in the sea. The lobster claws have been banded here to prevent a nip. The shellfish are usually placed in pens close to the harbour until enough have been caught to send to market. Clovelly has an annual crab and lobster festival in the summer, as well as a herring festival each November. The author takes his smokehouse along to the latter to produce fine Clovelly kippers and bloaters. (*Stephen Perham*)

Three views of lobster pots on Appledore Quay in the early spring of 1984. The small boy is Mark Sylvester, who is now thirty. Alongside in the bottom photograph is his mother Felicity Sylvester, who sold many of the crabs and lobsters caught in these pots and, as she says today, learnt to hypnotise the lobsters. (*Felicity Sylvester*)

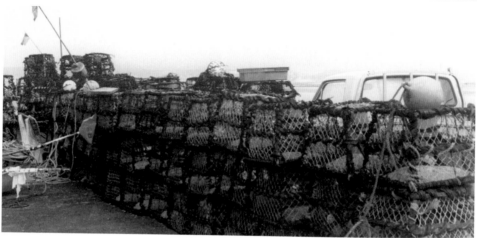

Fishing Boats

Fishing boats along this coast differ almost as much as the coast itself, which isn't surprising when one takes into account that design depends on the nature of the harbour the boat works out of and the type of fishing it undertakes. Other influences in design come from traditions handed down through generations; possible innovation on the part of either the boatbuilder or the fisherman who has ordered the boat; and the inclement weather.

Generally in the northern section of the Solway to Cardigan Bay it is the Lancashire nobby, sometimes called the Morecambe Bay prawner or shrimper, that rules supreme. Generally these were built in two sizes: larger ones upwards of 34 feet in length and smaller ones around the 30-foot mark. The bigger the boat, the further out to sea they worked.

The Isle of Man is the exception, and here various types of boats have worked over the centuries up to the time when fishing-boat design became the same throughout Britain: from the early Viking-influenced *scowtes*, to the smacks and luggers of the late eighteenth century, the Cornish-influenced *nickeys* and the Scottish-influenced Manx nobbies (which were totally unlike the Lancashire nobbies).

In the South, beach-based craft worked the Bristol Channel – the Tenby lugger, the Somerset flatner and Clovelly picarooner being three prime examples, although several others existed along the Welsh coast. Of course steam trawlers and drifters worked from the larger ports (Holyhead, Milford Haven, Swansea and Cardiff), as did deep-sea trawlers – under both sail and motor – from Fleetwood.

North West England and North Wales

A Lancashire nobby raising sail off Arnside. Judging by the two ladies aboard and the man with the boater hat, this vessel is not about to go fishing but is having an afternoon jolly. The nobbies were narrow vessels with a characteristic rounded counter stern, and were relatively shallow in draft with a cut-away forefoot. Accommodation consisted of a small cuddy beneath the foredeck. (*Lancaster City Museum*)

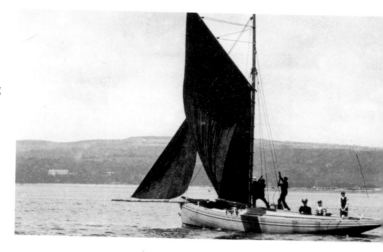

A nobby drawn up the beach at Fleetwood, with an audience of young boys and girls looking on. The man aboard appears to be inspecting or perhaps mending a sail, or something similar.

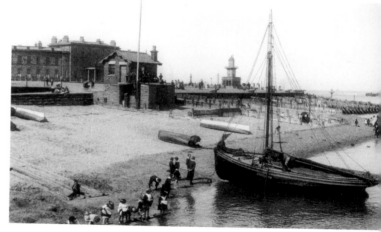

Boats moored off Morecambe, including three nobbies. Taking trippers out for a sail was a lucrative business for fishermen all along the coast of Britain where holidaymakers came. Morecambe was no exception and it was a good opportunity to advertise the fish upon one's mainsail. The boat in the middle is supporting (or being paid to) Morecambe Trawlers of Clarence Street and the Central Pier.

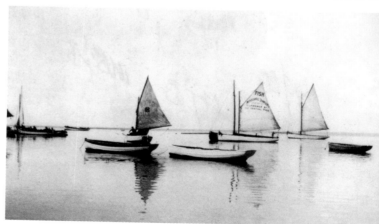

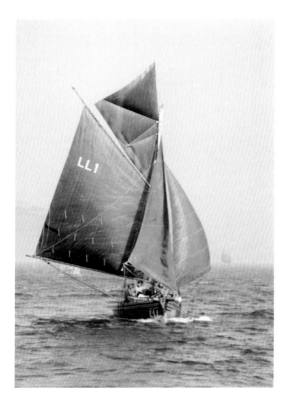

These nobbies worked all along the coast, trawling for prawns and whitefish, the smaller ones fishing shrimps. Many have also survived under private ownership. Here the *Arthur Alexander*, registered in Liverpool as LL1, is sailing in around 2004. She was built by Armours of Fleetwood in 1902 and worked as a fire boat during the war. She has sunk, been rebuilt and sailed all around the Irish Sea, and was for sale in 2010.

The 28-foot GRP plug nobby *Venture*, CH45, sailing in the Mersey nobby race in 2000. She was fished by Henry Evans of the well-known fishing family who worked from Lower Heswall. Note the beam trawl protruding over the stern. Many of these nobbies were built by Crossfields of Arnside who also opened a yard at Conwy. Many nobbies worked off the Welsh coast, as far down Cardigan Bay as Aberystwyth.

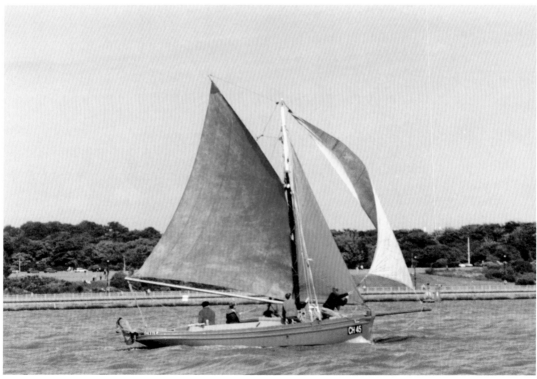

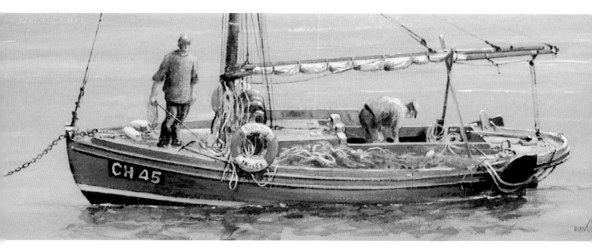

Venture fishing off Meols – an acrylic painting by David Wilson. She looks every inch a wooden boat even if she is built on a fibreglass hull. Henry Evans tragically died at the helm several years ago and Robert Beech from Hoylake bought her and still fishes off Meols. She has more recently had a rather unlovely wheelhouse fitted that spoils her lines, but which undoubtedly has made fishing much more comfortable. (*David Wilson*)

The nobby *Naiad*, built by Gibsons of Fleetwood in 1894. She worked out of Peel as PL57 and eventually was converted into a yacht. Many had a coach house built over the cockpit to allow accommodation to be built in. Here *Naiad* is photographed in Skippool Creek, near Fleetwood, on the River Wyre, in 2009.

The Nobby *Hearts Of Oak*

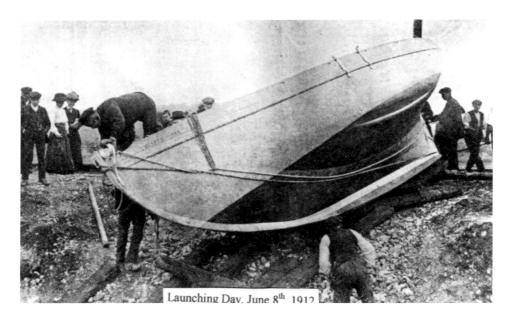

Launching Day. June 8th 1912

Launching Day, 8 June 1912. Built by John Randall Lester for local fisherman Peter Butler, using seasoned oak that he himself had felled, hence the name. John Randall Lester lived at Canal Foot, Ulverston, where Ainslie Pier had been built to moor craft waiting to enter the canal. The boat was built at the top of the beach. (*Jennifer Snell*)

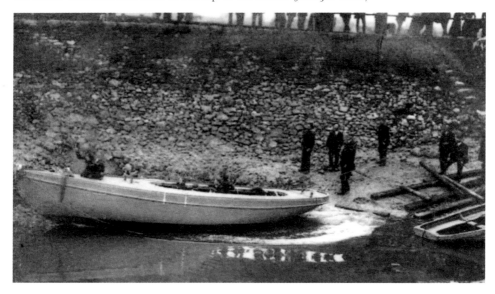

Here she is seen after reaching the water; the tide had risen, and the wooden runners on the right had been used to manhandle the vessel down the stony beach. Polly Butler is seen waving from the bow of the boat. (*Jennifer Snell*)

Fully rigged and alongside Ainslie Pier at low tide, the photographer obviously carefully posed this shot with family and friends of Peter Butler aboard. Note the leg to stop the boat falling over. (*Jennifer Snell*)

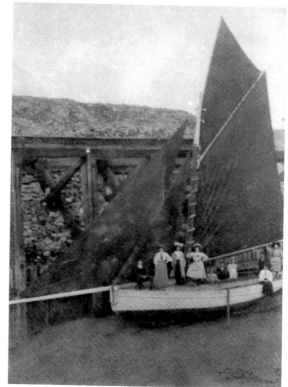

Ulverston Swimming Gala at Canal Foot around 1914. *Hearts of Oak* is being used as a floating diving pontoon across the entrance to the canal gates. Today's interfering health and safety brigade might have something to say about the lack of railings on both boat and harbour. (*Jennifer Snell*)

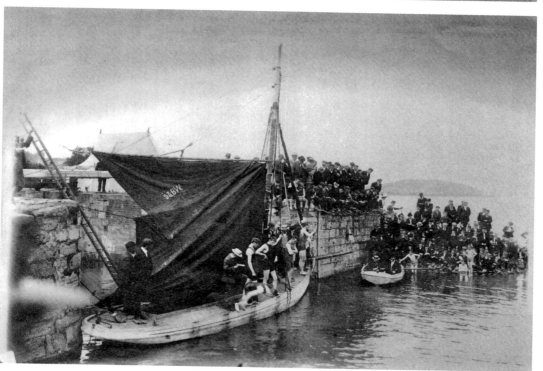

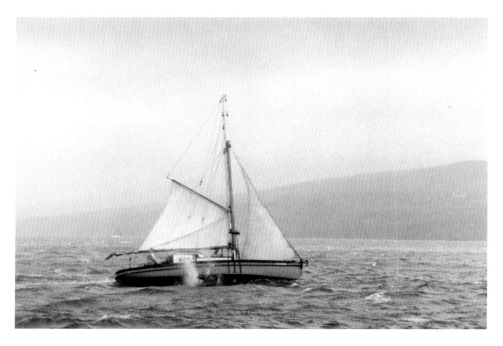

Isle of Man, 1994. The author first came across *Hearts of Oak* at the Peel Traditional Boat Festival in 1994 and here she is pictured sailing in a stiff breeze off Peel.

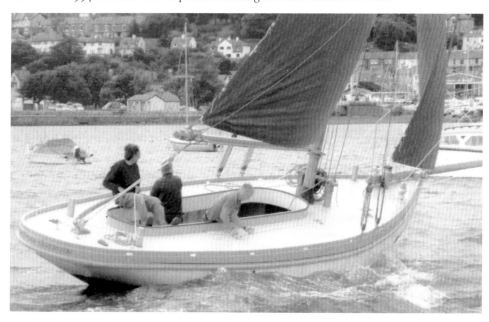

After a lengthy complete rebuild, financed much by the Heritage Lottery, *Hearts of Oak* was back in great sailing form by 2007, thanks to the hard work of Jennifer Snell and her husband, who found the boat rotting away in Northern Ireland, moved her back to England and arranged the rebuild. Scott Metcalfe, a boatbuilder from Bangor, North Wales, was responsible for the work done, and is seen steering the boat off Bangor. (*Mike Arridge*)

Two motorised fishing boats alongside at Conwy. Although nobbies worked from various North Wales ports, by the 1950s, MFVs, as they were called, were working from the same ports, drifting for herring and trawling. The varnished vessel on the outside is reminiscent of the Clyde boats. Note the mizzen sail has been retained to steady the vessel. (*Stuart Wood*)

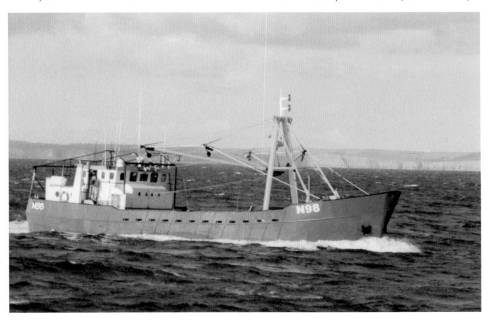

The mussel dredger *Bonnie & Kelly* after she had been sold to Northern Ireland from North Wales. Built in Borth, Wales, in 1990, she is over 25 m in length.

Isle Of Man

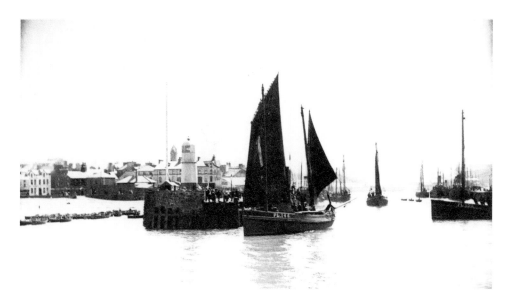

The nickey PL146 leaving the harbour at Peel. These luggers were copied from Cornish luggers that came up from the south to participate in the summer herring, and one theory as to the origins of the name is that it comes from the fact that many of the Cornish fishermen were named Nicholas. (*Pauline Oliver*)

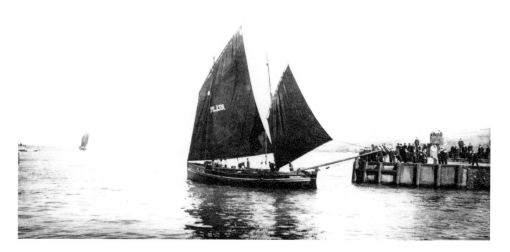

These powerful luggers are reminiscent of the Scottish luggers from the East Coast, as seen in Volume 1 of this series. They drifted for herring by dropping the mainmast with the net streamed out from the bow, leaving the mizzen sail up to keep the boat up to the wind. Raising and lowering the mainmast was a tiresome process, as was the hauling in of the train of drift nets. (*Pauline Oliver*)

The rig might be powerful but, at times, when the wind died, they were at the mercy of the tide. Here a nickey is being propelled forward using sweeps (long oars) while the sails hang limp. Sometimes the fishermen had to row for hours to get home. (*Pauline Oliver*)

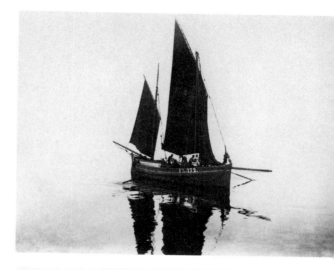

In the late nineteenth century, the fishermen saw how the Kintyre and Clyde fishermen were using ring nets with their Loch Fyne skiffs and nabbies, and they adopted the design to suit their more exposed waters by adopting the standing lug rig into what became known as the Manx nobby, though this bears no relation to the Lancashire nobby. At first they merely altered the rig of the dipping lugged nickeys, but then they built smaller nobbies with sloping sternposts like the Loch Fyne skiffs, and abandoned the nickeys altogether. Here some nobbies are moored off Peel pier. (*Pauline Oliver*)

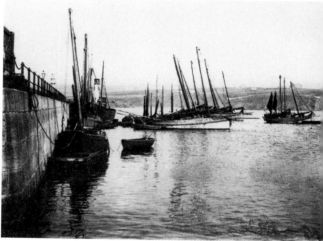

Occasionally one didn't make it home, as fishing was the most dangerous occupation in Britain. However, this nobby has come to grief within sight of home: the Peel-registered vessel comes ashore not more than half a mile from Peel's castle, seen in the background. Even if the boat was a wreck (and it is by no means certain that it was), at least the crew should have survived a grounding. (*Pauline Oliver*)

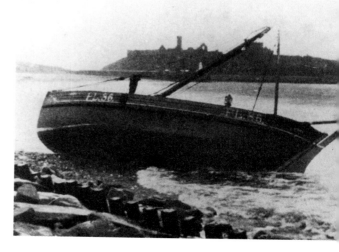

A nobby being poled out of Peel harbour under the shadow of the castle. Nobbies were generally about 40 foot in length, as against the nickeys which were nearer 60 feet. The nickeys were fully decked and had their accommodation aft, and the nobbies followed suit, with net rooms and fish storage further forward. This small nobby has the standing lug and a small foresail running out on the bowsprit.

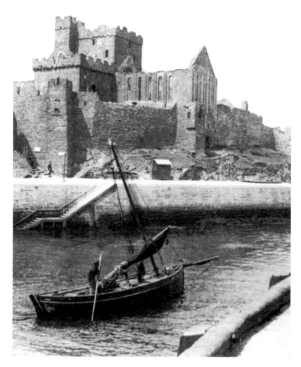

Boats had to be kept in good condition and here two crew are busy scrubbing and tarring the hull in Peel inner harbour. One wonders why some of the others aboard were not helping. Peel and Port St Mary were the main fishing harbours on the isle, though boats did land into Ramsey, Douglas and Castleton, and occasionally Port Erin. (*Pauline Oliver*)

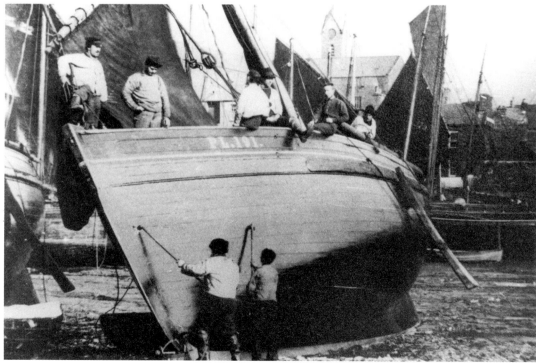

The Nobby *Gladys*

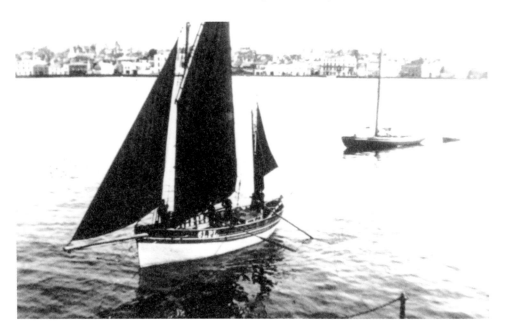

Gladys, 61PL, was built in 1901 for Peel fisherman Thomas Cashin by boatbuilders Neakle & Watterson, also of Peel. She was one nobby licensed by the Irish government to fish the mackerel off the south and west of Ireland.

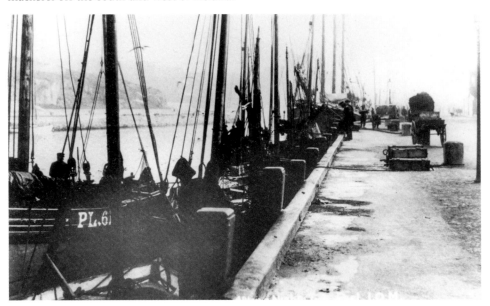

Here *Gladys* is moored among the Peel fleet. The letters and numbers of her registration have been reversed in accordance with legislation introduced in 1902. (*Manx Museum*)

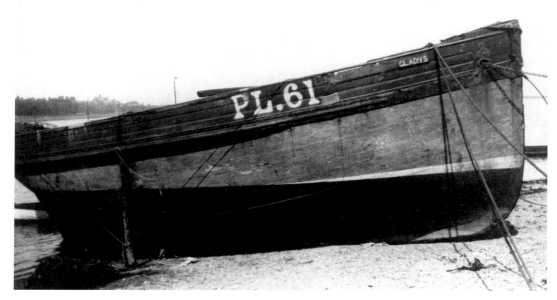

By the 1930s the herring fishing was in decline, and *Gladys* is seen here languishing on the beach. By this time the motorised boats were commanding the fishing, and the sloping sternpost of the nobbies was deemed unsuitable for motorisation (even though *Gladys* had had an engine fitted previously), unlike the canoe-sterned vessels.

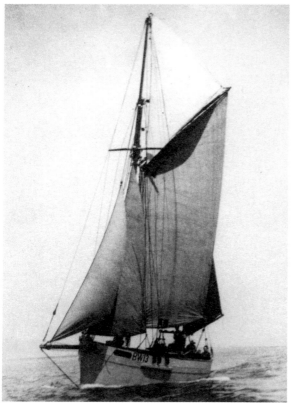

Gladys was sold to Barrow-in-Furness in 1936 and re-registered as BW13. Here she is shown with a gaff ketch rig with foresail and jib. She was later sold to Plymouth, where she was taken by road, sailed over to Brest in 1992 and thence to Kinvarra on the west coast of Ireland, where she was ashore until sold to Paul and Jo Welch in about 2005.

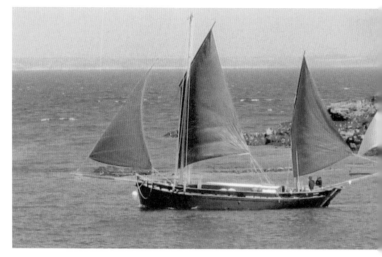

Gladys sailing off Mousehole, Cornwall, in 2008 after her new owners had restored her in West Wales. She eventually was sold to Charlotte White and her partner Spike Davies, who are now living aboard her in Falmouth while they totally rebuild her. She remains the oldest surviving Manx nobby.

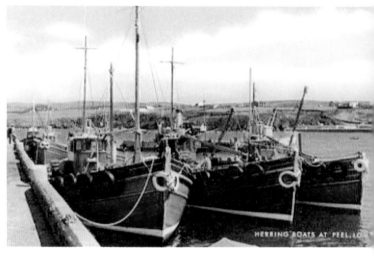

Peel became renowned for its ring-net herring boats and here three boats are moored on Peel's pier. Like the Clyde boats, the hulls of some of the boats were varnished, though the boats here could just as well be from the Clyde.

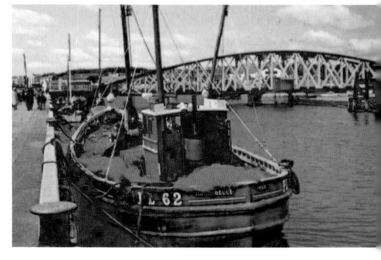

Manx Belle, PL62, lying in Ramsey, Isle of Man, was built by Tyrrell's of Arklow in 1943. There were several vessels: *Manx Beauty* (1937), *Manx Fairy* (1937), *Manx Clover* (1941), *Manx Rose* (1942) and *Manx Rose* (1958).

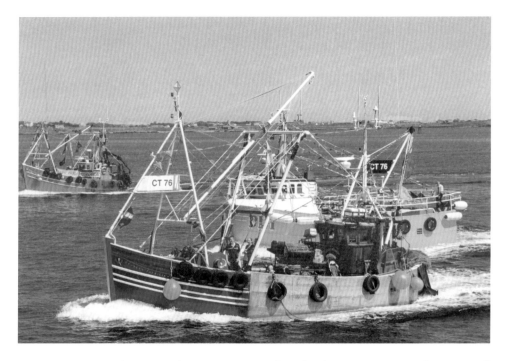

Trawlers racing in their annual regatta in 2010. The Isle of Man continues to have a small fishing fleet, though much of the fleet is confined to scallops. (*Mike Craine*)

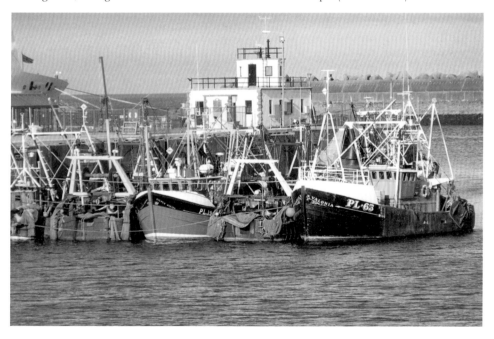

Boats off Douglas pier. The nature of fishing means that much is transported to the mainland, and so boats land at Douglas to allow the fish to be taken by ferry. These vessels, seen in 2010, are all either trawlers or dual-purpose boats. (*Mike Craine*)

Welsh Beach Boats

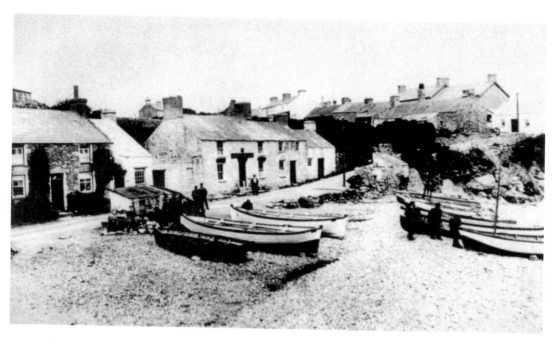

The beach at Moelfre on the east side of Anglesey in about 1920. These small open boats, with names such as *Seagull, Sovereign, Stag* or *Shamrock*, sailed out to check their nets each day during the October–February herring season. Moelfre men were renowned seamen, many of whom sailed the oceans aboard large trading vessels, only returning for the lucrative herring season that made this small village home to Anglesey's major herring fishery.

At the tip of the Lleyn Peninsula, the tiny village of Aberdaron once had a vibrant lobster fishery, as did the nearby island of Bardsey, according to the Revd William Bingley in 1800. As far back as the fourteenth century, it is said that it was a principle herring station. Small, open, double-ended vessels serviced the fishing. The herring declined and lobster fishing seemed to occupy the fishermen, who ran boats of out *Porth Meudy* or Fishermen's Cove. However, double-enders were unsuitable for lobster fishing and many capsized; thus the boatbuilders added a transom stern to the boats to enable pots to be hauled over the stern. Today several of these sailing boats survive, albeit for pleasure with a modern rig, and race in regattas during the summer season.

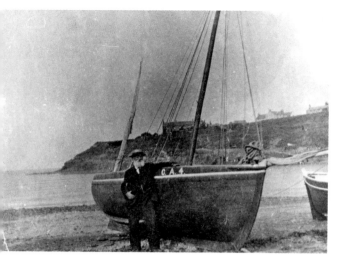

Captain Evans with his herring boat at Aberporth, Cardigan Bay. Aberporth herring were renowned throughout this part of the country, as they had been in Nefyn, to the north. The fishermen used a method they called *tranio* or *setin*, in which they anchored the net to the seabed using heavy stones. Herring drifting was known as *drifio*.

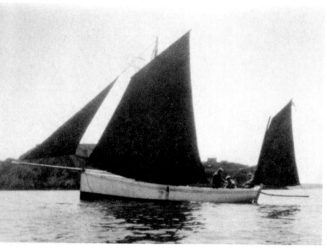

Tenby in Welsh is *Dinbych-y-pysgod* which literally means 'the little fort of the fishes', a reference to the fact that in medieval times it was the principle fishing station in South Wales, and had had a quay since 1328. The boat is a Tenby lugger of the late nineteenth century, a transom-sterned boat locally built.

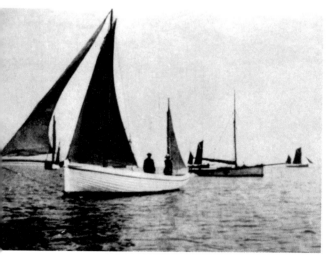

These luggers were solidly built craft, and were used for all manner of fishing including drifting for herring, line fishing and oyster dredging. Oyster grounds lay off Stackpole and to the north of Caldey Island. In summer, with Tenby becoming a respected watering place, fishermen operated bathing machines and took trippers out around the bay in their luggers.

The Bristol Channel

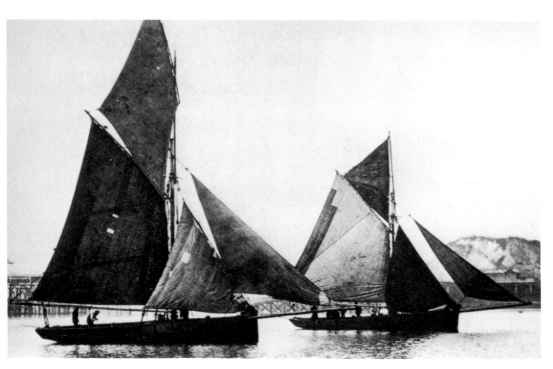

Oysters were also prolific off Mumbles, at the western end of Swansea Bay, and off the Gower Peninsula, and these were dredged by small local boats similar to the Tenby luggers. However, in the early 1900s, bigger smacks from the east coast of England, in their continual search for new grounds, started fishing, and the local boats were unable to compete. Thus they copied the smacks (including buying in a few smacks from the East Coast) and here are two local smacks, *Snake* and *Hawk*, which were built in Appledore.

A Milford smack, M99; although its name is not known, it could well have been built on the east coast of England. Smacks tended to trawl, and the beam trawl can be seen resting on the port side of the vessel.

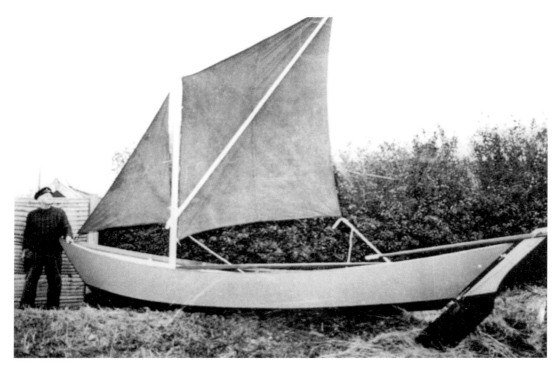

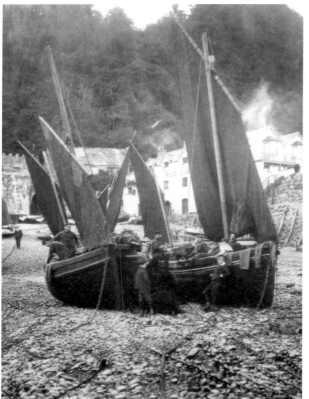

Harold Kimber with a flatner. Kimber – known as Kim – was from Highbridge and was probably Somerset's best-known boatbuilder. The flatner was the river and sea craft of Somerset and came in various sizes depending on use – from the smallest turf boat to the largest sea boat. Here he is pictured with one of his boats, which survives today in the Watchet Boat Museum.

Clovelly has had its own herring fishery for generations. Here on the beach are two larger herring boats, while behind on the extreme left of the photo are at least two picarooners. The difference in size is obvious and it is easy to see how the smaller boats got out fishing before the big boats, which couldn't be lifted down to the waves. Clovelly hasn't changed much since this photograph was taken, except that the boats are fewer and mostly motorised.

A Clovelly picarooner in around 1998. At the time this was the last remaining picarooner afloat though several remained in various states of disrepair. This one would be sculled out to where the net was shot about 200 yards upstream off the waterfall. The boat would then drift with the tide downstream with the nets fixed to the bow. Hopefully the net would be full by the time the boat had drifted 300 or 400 yards past the harbour.

In June 2008 a new picarooner, built by students from the Falmouth Marine College and bought by Clovelly Estate owner John Rous, was delivered, and Stephen Perham has since used her for his annual herring fishing. Here the boat is seen out for a sail with the author aboard. (*Simon & Ann Cooper*)

Deep-Sea Fishing

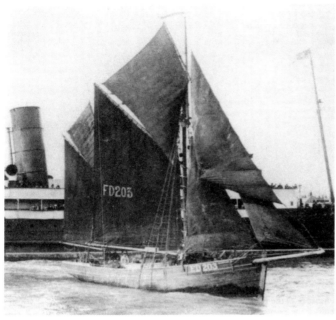

A fine view of the sailing trawler *Desdemona*, FD203, as she sails past an Isle of Man ferry. These ketch-rigged smacks were among the first British boats to exploit the lucrative cod fishing off Iceland and in the White Sea. Various ports around the coast developed this way – Hull and Grimsby for instance – with this boat coming from Fleetwood. However, the deep-sea fishery didn't amount to anything until the last decade of the nineteenth century when there were some 95 sailing boats working from there. Before that it was simply a base for a small inshore fleet. (*www.rossallbeach.co.uk*)

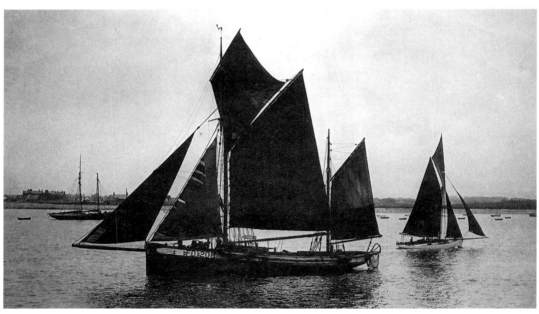

The trawler *Margaret*, FD208, and a nobby passing each other on the River Wyre. The *Margaret* was the first of Fleetwood's boats to have a petrol motor installed. However, with the development of steam trawling, Fleetwood's fleet grew fast, and the sailing fleet declined accordingly. (*Sankeys of Barrow*)

A lone fisherman poles his mussel boat towards the shore of the River Lune. Nobody quite knows who this fellow is, but the boat is just a small clinker-built boat of about 12 feet in length that was typical of the boats of the mussel fishermen of the area. There's a number – 28 – painted on the side, which would reflect the fact that the boat was licensed locally for the work it did.

Tom Smith's whammel-net boat *William Arnold*, LR173, which was built in Overton by Bill Bayliss. This is a fibreglass boat, the mould coming from a boat built in Yorkshire. Although not exactly a boat that pulls any heartstrings, it is none the less a down-to-earth working boat that fulfils a purpose at a minimum overhead.

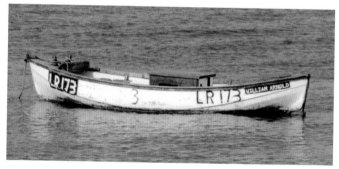

A River Dee salmon boat built by David Jones of Chester. These boats were developed by narrowboat builder Joseph Taylor at the beginning of the twentieth century for draft netting (seine netting) on the River Dee. They were sprit rigged craft with a platform at the stern for stowing the net prior to shooting. Several still survive and can be seen along the banks of the river in places.

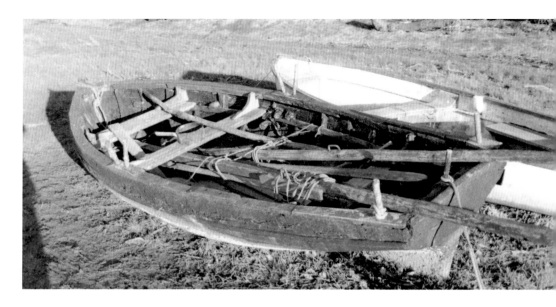

This one was found lying on the riverbank below Hook in 1998 and was typical of the type. Built locally of, some say, timber 'recycled' from the dockyard at Pembroke Dock, they are generally tarred inside and out, and again the cynics say this is to avoid detection at night.

Boat number K5 was rebuilt by Hugo Pettingel a couple of years ago. (*Hugo Pettinfer*)

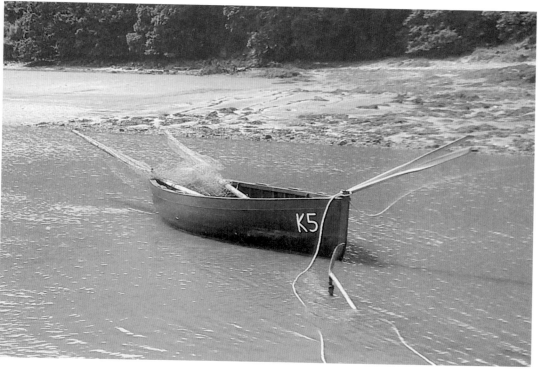

K5 lies on the river at Llangwm once again with her compass net in the stern of the boat. Today she is fished with the compass net by local fisherman Alun Lewis of Landshipping. (*Alun Lewis*)

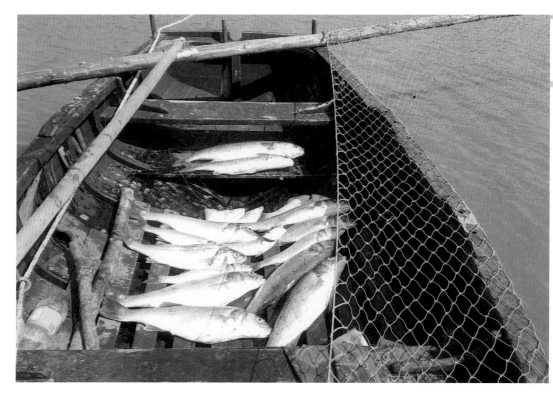

K5 with a selection of fish caught in 2013, mostly sea trout (sewin). (*Alun Lewis*)

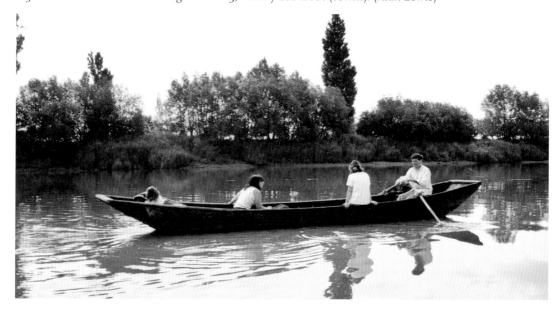

Simon & Ann Cooper's long-net punt from the River Severn. Flat-bottomed punts such as this were used above Newnham and were developed to suit the conditions of the river. This one is some 26 feet in length and built in oak so that with the net aboard it weighs almost a ton.

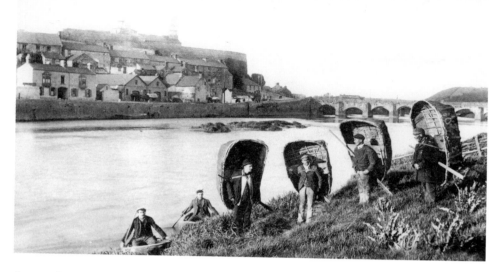

Carmarthen coracle fishermen in 1898. The fishermen here are posed with their coracles over their backs. To fish they drifted down the river with the ebb and then would simply walk back along the riverbank instead of having to fight the current upstream. How simple is this mode of fishing!

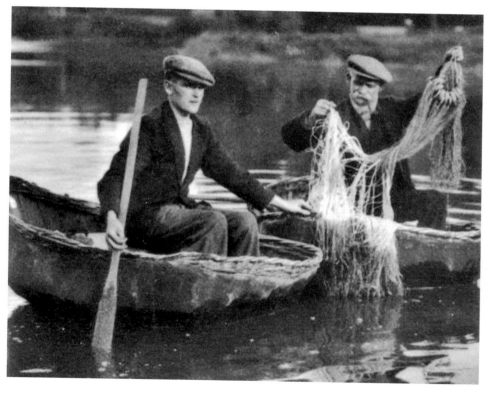

Coracle fishing involves two coracles. The fishermen suspend a net between them and each feels for vibration in the net from a salmon becoming entangled. Today licences are severely restricted.

Carmarthen fisherman Raymond Rees demonstrating how he carried his coracle on his back in 2003. Raymond was descended from a family that had been fishing the river for generations, and he was able to explain all the finer points of the river. Sadly he has since retired, though others do continue the practice of coracle fishing on the River Towy. The coracle Raymond makes is built of an ash frame with calico and bitumen covering it. However, some of today's coracles are made from fibreglass.

Coracle builder Peter Faulkner with his Teme coracle. Peter builds coracles the way they were done in early times, using willow and hazel to form the basket, and then he uses animal skins to cover the framework. Each coracle takes many hours of work. Peter has also built several Irish currachs in a similar way, as well as a River Boyne coracle. He has voyaged widely along rivers in his creations.

Fisher Folk

Whereas fishing methods and fishing boats are the tools of the fishermen, it is the social history of the fisherfolk themselves that in some ways is the true story of fishing. These fishers survived in their insular communities all strung out along the coasts of western England and all of Wales, and each had their own traditions and ways of living and fishing. Not until twentieth-century fishing displaced these communities in favour of large ports did these communities change. Son followed father who had followed grandfather into fishing – there was generally no other choice. On some parts of the coast, especially in Wales, men went to sea aboard the large trading vessels that plied the world's oceans, and often only came home in the autumn to fish the lucrative winter herring. At times it is said they could earn in two months the same as they earned the rest of the year.

Throughout much of Britain, fishing communities tended to be separate from the general populace, often set aside at the end of the town. Often these communities weren't just about fishing, and boatbuilding was an equally important part of the story. The boats had to be built, and the West Coast was home to several itinerant boatbuilders, who would travel to a particular settlement to build a boat for some individual. Boatbuilding yards – or more likely available waterside fields – spread in the nineteenth century, so that a whole host of builders were producing small skiffs. Sailmakers and blacksmiths contributed, as did the various net-makers. Once the fish were landed, they had to be sent straight to market, hawked about the locality or processed. Processing usually involved a either salt-cure or smoke-cure until the advent of refrigeration, deep-freezing and processes such as fish-finger production.

Boatbuilder Joe Dowthwaite in his workshop, alongside the nobby *Nance*. The boat had been built in 1914 and Joe had bought her as a wreck. He had served his apprenticeship with John Tyrrell & Sons of Arklow before moving to Barrow-in-Furness, working for Vickers until his retirement in the early 1970s. He then had a small shed at North Scale, Walney Island, where he restored and repaired wooden boats with his son Charlie.

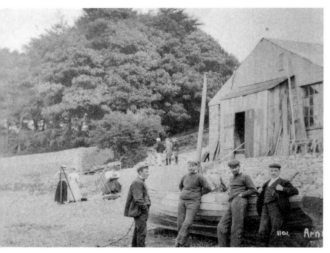

The small village of Arnside, alongside the River Kent, became synonymous with the Lancashire nobby after Francis John Crossfield started building these boats in the middle of the nineteenth century. Here he is seen standing on the right outside his shed at Beach Walk, Arnside, in the late part of that century.

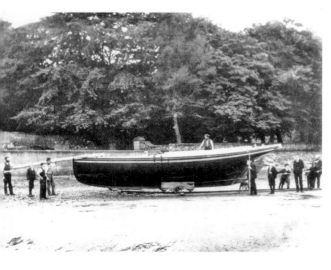

The nobby *Red Rose* at her launch at Arnside in September 1895. This boat was one of the largest nobbies built by Crossfields. (*Lancaster City Museums*)

Another Crossfield-built nobby, *Maud Raby*, sitting on a trolley on the beach by the shed. Francis John is on the deck watching the rigger at work up the mast. In 1905 another yard was opened in Conwy, then another one ten years later in Hoylake, although this last didn't survive long. The Arnside yard closed in 1938 after building over 400 boats. (*Jennifer Snell*)

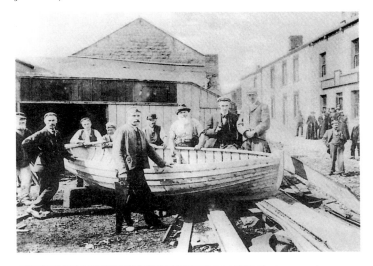

Jack Woodhouse had a small boatbuilding yard at Overton where he built smaller craft such as the whammel boat here.

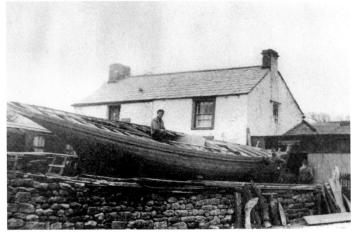

However, he did also build the odd nobby; here one is about to have her deck fitted.

Three salmon fishermen from the River Lune posing for the camera while waiting for the tide, perhaps taken by one of the many holidaymakers at Sunderland Point. Note their ganseys, the uniform of the fishermen throughout the country.

Three fishermen at rest outside their fishing hut at Bazil Point alongside the River Lune. Sometimes the weather wouldn't allow them to work; at other times the tides were either too low, too high, at springs or neaps. Sometimes the fish just weren't there. Fishing has always been a gamble with highs and lows. Some made themselves wealthy while others worked all their lives for a pittance.

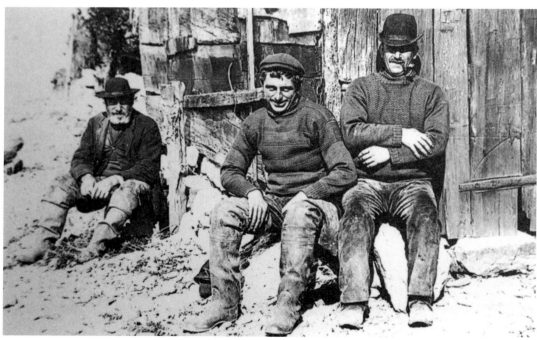

In small communities, such as here at Sunderland Point on the estuary of the River Lune, most of the local population were involved in the local sea work – pilotage, fishing, salvage, life-saving. Here, several old salts pose with some of their families.

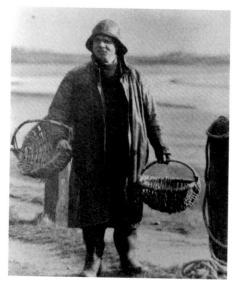

Local fisherman William Townley at Sunderland Point in 1932. He carries two tiernals, which were locally made wicker baskets used to carry all sorts of fish and shellfish. Like most other aspects of fishing, the traditional tiernal has been replaced by plastic fish boxes and nylon mesh bags.

Sunderland Point fisherman Tom Smith alongside his whammel boat *Mary*, LR53, in 2009. Tom has lived in the hamlet all his life, as did his father for most of his. He works four boats, whammel-netting for salmon, collecting mussels and cockles, setting stake nets in which he catches small fish such as flounder, and moor netting for whitebait. He was also the last fisherman to shrimp with a horse and cart. Furthermore he has always supported his family's diet with a sizeable market garden, supplying them with vegetables and selling any surplus.

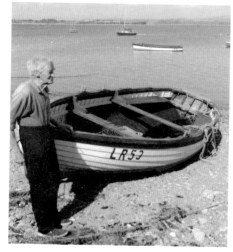

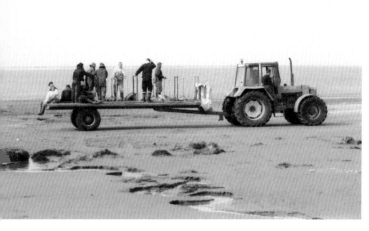

Today's fishermen about to set off to the cockle-picking areas in Morecambe Bay. Whereas of old the fishermen would take a horse and cart out onto the sands, it is tractors that are the preferred mode of transport. At times up to fifty pickers, often transient workers from Eastern Europe (seldom do Chinese pickers appear since the 2004 disaster), can be working a number of cockle areas, depending on closures enforced by the Sea Fisheries Committees.

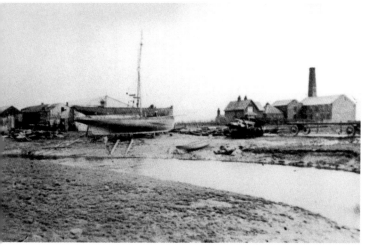

Nobbies under construction at Latham's yard, Crossen Sluice, near Southport in the 1890s. Boats were usually built in the open, close to the beach, and nobby building was not confined to Arnside, other builders being in Barrow-in-Furness, Millom, Glasson, Fleetwood and several in various Welsh villages, the most southerly being Criccieth where one nobby was built in 1913. (*Len Lloyd*)

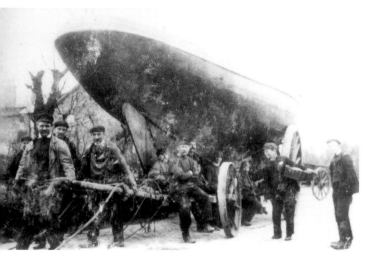

The launching of a nobby at the Sluice from Wright's Yard in Shellfield Road, Marshside, Southport. The vessel is being moved upon a trolley with huge iron wheels, pulled by men and horses. The men appear to be resting and posing for the photograph while a young chap carries something in a basket: their lunch maybe?! The elliptical counter stern is a characteristic of the nobby, although this one seems to be more spoon-shaped than others. (*Len Lloyd*)

Old- and new-style nobbies at Latham's Yard in the 1890s. The Fleetwood-born naval architect William Stoba, who worked at both Gibsons and Armours of Fleetwood, is largely acknowledged as being the designer of the cutaway forefoot during the latter part of the nineteenth century. Before this, the forefoot was deeper as in similar smacks of the era, though the cutaway improved performance of the rig. (*Len Lloyd*)

An excellent view of the decks of the nobbies and also a reminder that fishermen, by both nature and necessity, used their craft to earn other forms of income when not fishing. Here nobbies on Southport Pier, on 15 August 1897, have time off for 'quality sailing' trips around the bay over the Bank Holiday weekend. Boats are generally registered at Liverpool (LL). (*Len Lloyd*)

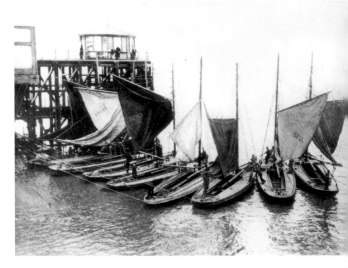

Conwy fishermen aboard the 1944-built *Ocean Reaper*, LK64. This boat was built by Millers of St Monans as a herring drifter and she eventually was sold into private hands, refurbished and sailed to Sri Lanka in around 1982. (*J. Owen*)

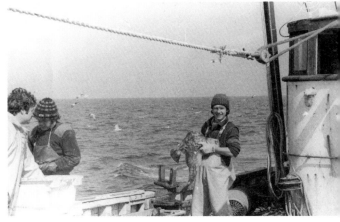

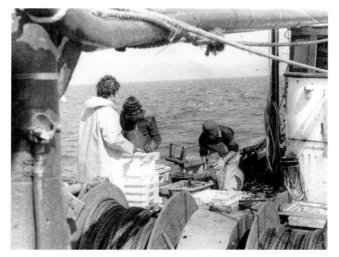

Ocean Reaper was skippered by John Owen of Conwy and here she is fishing in March 1981 some 30 miles north of Great Orme's Head. The winch is clearly seen in the foreground and the crew are busy sorting and gutting the catch. I remember being aboard this boat prior to her departure to the East and noticing what a sturdy craft she was. (*J. Owen*)

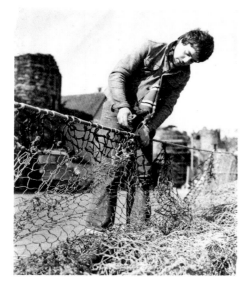

John Owen repairing his nets on Conwy Quay in 1977. Fishing wasn't just about being out at sea. Nets had to be repaired constantly, especially when trawling on rough ground. However, the man-made netting here does not have to be treated like the nets made of cotton and hemp which have been barked in a solution of oak bark or cutch, a resin from the acacia tree. Nevertheless it was a back-breaking business, and finger wrecking in cold weather. (*J. Owen*)

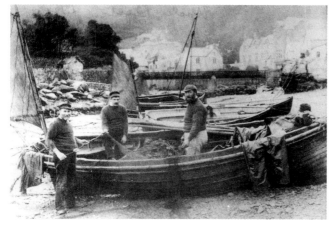

Fishermen sorting their nets at Lynmouth, in Devon in around 1890. These sorts of nets had to be barked to stop them rotting in the seawater. These men are probably preparing for the herring season in autumn and the two boats beyond the one in the foreground are reminiscent of those from Clovelly.

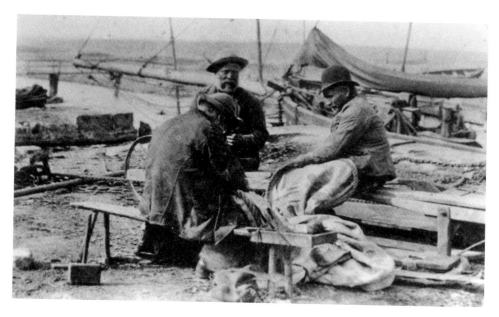

In the days of sail it wasn't just the nets that had to be repaired. Here old salts in Porlock Weir are repairing sails. The boat behind is a trading smack so it isn't possible to tell whether these folk are fishermen or sailors from the smack.

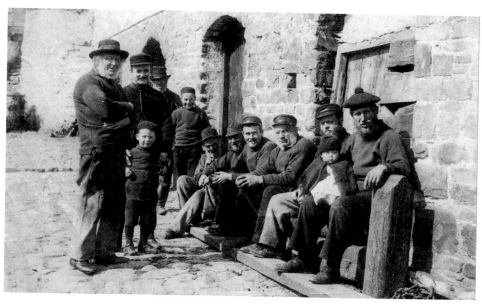

A group of fishermen from Clovelly posing for the camera outside the Red Lion in the 1880s. On the left is William Bates and next to him Tom Pengelly, master-mariner, fisherman and lifeboat coxswain, with the local cobbler Alexander Pedlar wearing the bowler hat. From the right is fisherman Robert Badcock with his son Frank on his knee; John Whitfield, another master-mariner; Stephen Headon, fisherman; and William Prince, also a fisherman. The similarity of the clothing is noticeable – ganseys, serge trousers and hats – and amazingly the little boy is dressed in the same manner. (*Stephen Perham*)

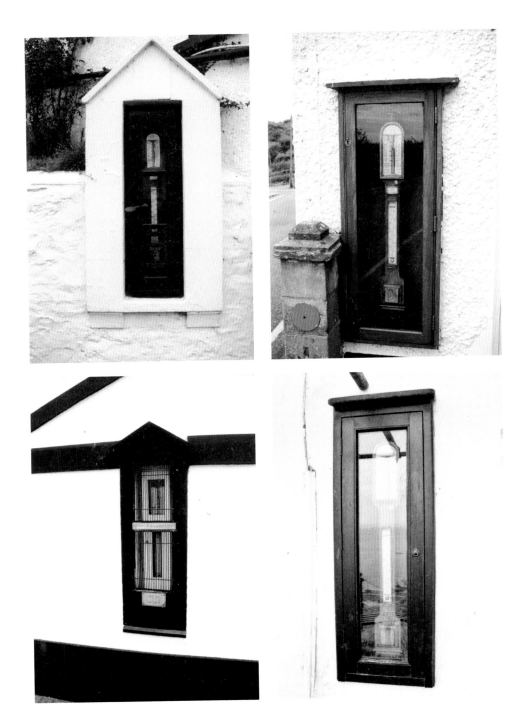

Four different barometers in their housing in four different locations – Llangrannog, Aberporth, Watchet and Clovelly. Barometers such as these were installed in many fishing villages after disasters left fisher families without any breadwinners. They were to encourage fishermen to watch for signs of adverse weather; some were financed by the RNLI, and others by the local council.

Along the Coast

The West Coast and the whole of the Welsh coast are served well with places of refuge, and between these are many beaches and coves where boats can land. In the North, the main ports are Maryport, Workington and Whitehaven; Morecambe Bay encompasses various harbours and Fleetwood, as we've seen, became home to a vigorous deep-sea trawling fleet. The Isle of Man, spectacularly apart from the rest of Britain, has harbours such as Douglas, Ramsey, Peel, Port St Mary and several smaller coastal settlements. Rivers such as the Ribble, Mersey, Dee and Conwy had their own harbours and the coast of Wales is inundated with inlets and coves. In Cardigan Bay the principal harbours existed at Aberystwyth, Aberaeron and Fishguard. In the South, Milford Haven, Swansea and Cardiff had their own fleets on the north side of the Bristol Channel while the south side is somewhat sparse – only Minehead, Ilfracombe and Clovelly having any pretence of a harbour.

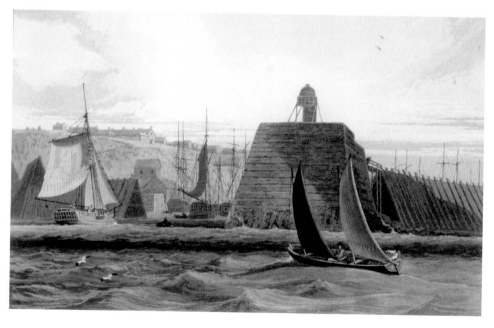

A small wherry heading into the harbour at Maryport, Cumberland, by Richard Ayton and published in William Daniell's *Voyage round Great Britain*, 1814. Daniell describes the harbour as being 'very small, and ill-suited to the wealth and commercial importance of the town. The channel is so narrow in parts, that two vessels can lie in it abreast.' The breakwater on both sides of the entrance was made from wood, which appear to have made the harbour uncomfortable and insecure. The schooner-rigged wherry was a common sort of fishing vessel in use throughout the Irish Sea and came in two sizes – the smaller fishing type, as here, and the larger type often associated with smuggling between England and the Isle of Man, which was not part of the Crown.

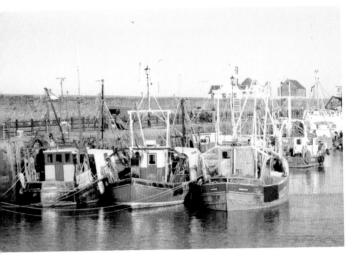

Fishing boats at Whitehaven in 2005. Daniell considered the harbour here to be both 'spacious and secure'. Coal was the major export, which was the main reason for building the harbour in the first place. He notes 'hemp, flax and timber' as being the main imports. A century earlier, Daniel Defoe found a port grown up from the coal trade into one of the most eminent ports in the country, just behind Newcastle and Sunderland. Today it has a major marina, a bit of fishing and tourism.

Fishing boats alongside at Barrow-in-Furness. Barrow could have become a major fishing port, but instead it became a major builder of naval and merchant ships. Being close to Fleetwood, it is perhaps strange that it didn't have more fishing boats. William Ashburner set up a yard in 1847 and later moved to Hindpool. In 1867 *Punch* magazine noted that the town had grown up from 'the quiet coastal nest of some five score fishermen' into a workplace of 20,000 iron-workers. Vickers, the shipbuilding firm, started in 1897 and are still there building ships.

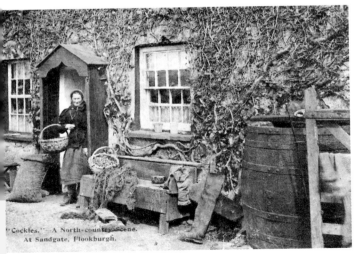

" Cockles," A North-country Scene. At Sandgate, Flookburgh.

Mrs Burrows of Guide's Cottage, Sandgate Shore, Flookburgh, the wife of a fisherman, with a tiernal of cockles, showing that Flookburgh was not wholly dedicated to shrimping. Many cottages were just the same, selling their catch from home. Note the fisherman's high boots leaning up by the barrel. The hessian sack was probably full of cockles too. (*Jennifer Snell*)

Three fishing boats moored off the stone quay of Morecambe in 2009. These are very different to the mussel boats and nobbies, even if many nobbies have survived. The outer two boats trawl for prawns during the summer.

A postcard view of MFV-type fishing craft at Fleetwood, alongside Jubilee Quay, 1960s. Jubilee Quay was the home to the inshore fleet while the deep-sea fleet worked from the Wyre Dock, and at the time the Fleetwood fleet numbered some 100 vessels.

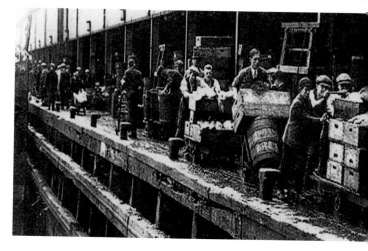

A busy scene on Fleetwood's main fish quay with lumpers and labourers, the former being the men who unload the vessels, with the labourers moving the fish around. Here they are moving boxes and barrels of fish about.

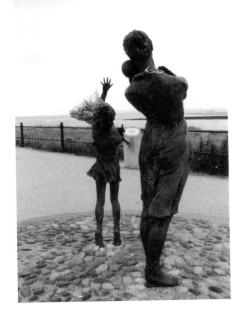

A tribute to the fishermen and their families at Fleetwood. These two sculptures – the little girl has had a bouquet of flowers added – stand at the entrance to the River Wyre, waving after having seen their husband/father's boat coming home, as had generations of spouses and their children. The relief on their faces is mixed with apprehension.

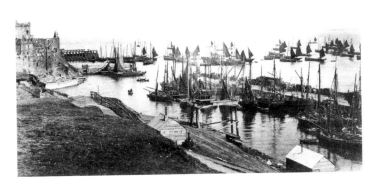

Peel, Isle of Man, with the fishing fleet anchored off, though some boats are moored in the inner harbour, along with a few trading vessels, one of which is a steamer. The boats are generally nickeys, although there are at least two boats from Northern Ireland. A steamer is also anchored off the quay while a few Manx nobbies are moored off the wooden pier.

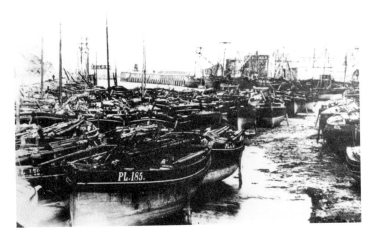

Boats again in the inner harbour at Peel, though these are mostly Manx nobbies. Note how the legs keep the boats upright when the tide ebbs. It would appear this photograph was taken in winter with the masts and spars of the boats lowered and neatly stored on deck. (*Pauline Oliver*)

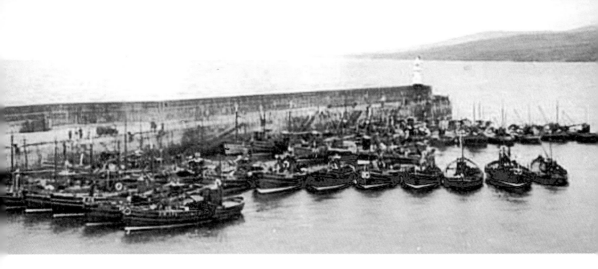

The ring-net fleet in Peel in the 1960s. Note how the pier has been extended and built in stone, as against the wooden structure in the middle photo on page 86. Although many of the boats would belong to Peel, some would have come from the Clyde.

Richard Ayton's view of 'Hoyle-lake, Cheshire'. Only a few wherries and smacks sit on the sands with rabbits living in the sand dunes. Today's seaside resort grew up from the fishing hamlet of Hoose. Hoyle Lake was actually the channel between Hilbre Island and Dove Point on the mainland and gave its name to the town. Hoyle Bank was a sandbank protecting Hoyle Lake and thus presenting a fine anchorage for sheltering ships and boats. Two lighthouses marked the anchorage in the late 1700s; one was a wooden structure, the other built of brick.

A few miles upstream from Hoylake is Parkgate. Here boats are being unloaded of their cockles. The small boats are unusual in this area in that they set a jigger rig with a sprit mizzen sail. Cockles were once prolific on the sands of the River Dee.

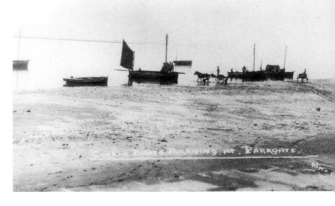

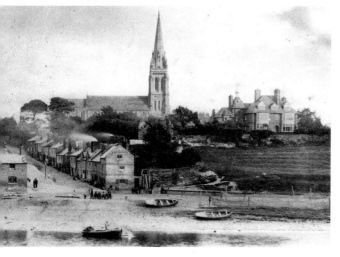

The bottom of Greenaway Street, Chester, the home of many of the fishing families of the city in 1900. Three Dee salmon boats, two on the riverbank and one afloat, are seen, as is a group of fishermen. Although the area still exists, the houses no longer belong to fishermen, but to city gents working in the city.

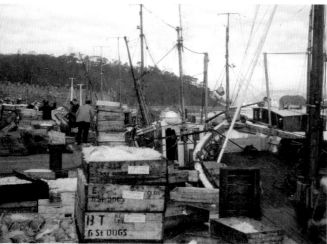

Conwy Quay in the 1950s. Fish is being unloaded into the traditional wooden fish-boxes and covered in ice. The quay would be bustling with activity, as were dozens others around the country. Today European legislation tries to get fish landed in 'designated' ports, although in parts of the Continent, especially in the Mediterranean, their plan just does not work! (*Stuart Wood*)

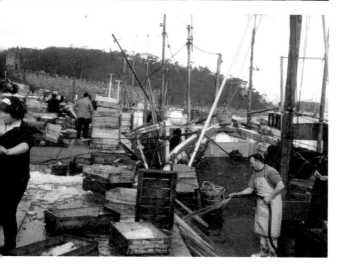

The same quay some minutes later after the boxes of fish had been removed, possibly by the woman on the left. The fisherman is now hosing the area down. Both this photograph and the previous appear to have been taken from points about 3 feet apart. Together they form an interesting study of the unloading process.

At the same time, whitefish was landed by a growing fleet of steam trawlers. Here a mixture of trawlers and drifters are landing at the market. (*Scolton Manor Collection, Pembrokeshire MuseumService*)

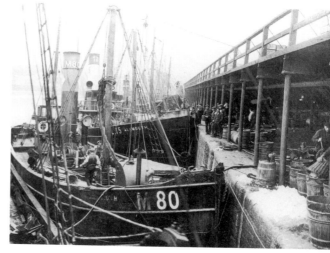

Fish needed to be kept cold to stay fresh, and here Norwegian ice is being unloaded. By 1901 there were two ice factories. (*Scolton Manor Collection, Pembrokeshire MuseumService*)

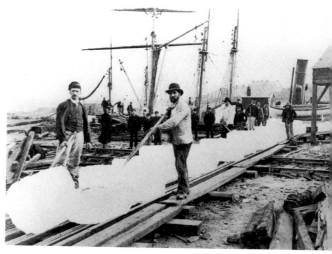

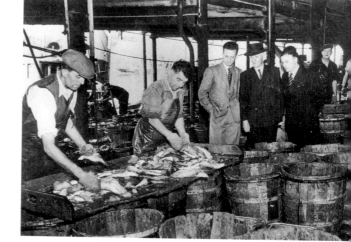

The Milford fish market in the 1930s. (*Scolton Manor Collection, Pembrokeshire MuseumService*)

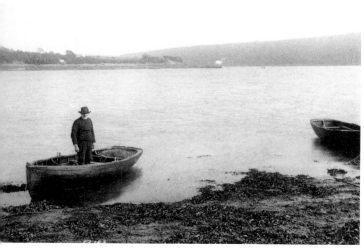

A lone fisherman with two compass-net boats on the River Cleddau.

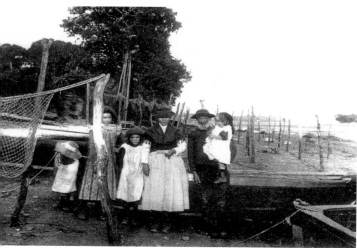

Here a fisherman poses with his wife and four children at Black Tar Point, close to Llangwn on the River Cleddau. There are three boats in the picture and a net drying. The fisherman's wife could well have been one of the fishwives who hawked the fish throughout the locality, sometimes walking miles with fish slung in baskets over their shoulders. These women became renowned after one, Mary Palmer, was featured in the *Daily Mail* in the early twentieth century.

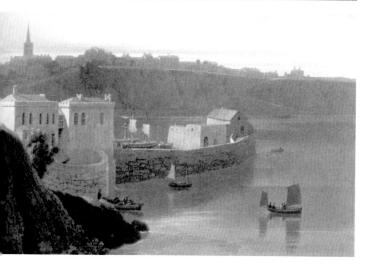

Richard Ayton's view of Tenby – the little fort of the fishes – which was the centre of a vibrant fishing industry for centuries. Pembrokeshire was noted as being 'enclosed with a hedge of herring' by George Owen of Henllys in the seventeenth century. The boat in the foreground would appear to be the forerunner of the Tenby lugger.

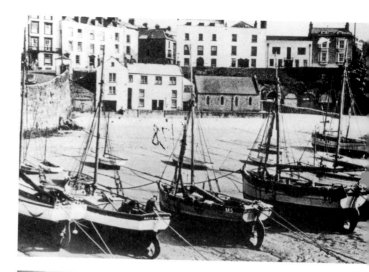

Here transom-sterned Tenby luggers jostle in the harbour in front of St Julian's chapel, with fishermen's sheds in the arches.

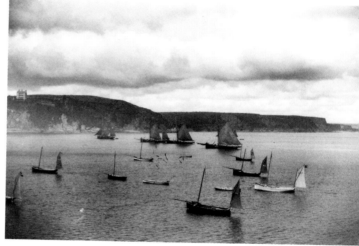

East Coast smacks and Tenby luggers moored off the town. With good fishing around, the smaller luggers had to compete against the bigger trawlers for the oysters, and it didn't take long for the beds to be denuded.

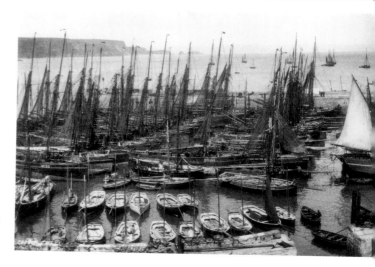

Trawlers from Brixham and Dartmouth, along with some from Milford Haven, moored up in Tenby. The smaller luggers are moored in the foreground.

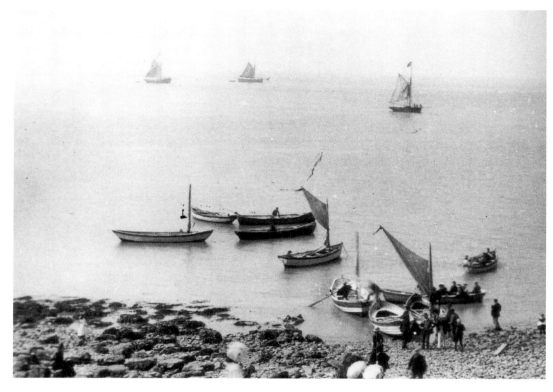

Small Weston-super-Mare flatners beached at Weston, prior to taking trippers out. The Parrett flatner on the left contrasts with the larger Weston boats.

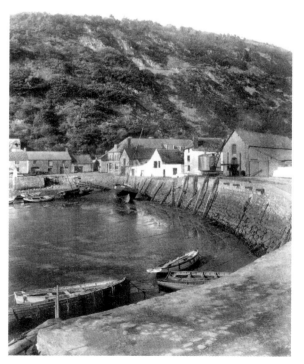

Minehead harbour. There's a saying: 'Herring and bread, so the bells of Minehead'. In the seventeenth and eighteenth centuries these quays were crowded with smokehouses producing red herrings and other smoked herrings for the local trade. Some 4,000 barrels were also exported in a good year. Today you wouldn't know a herring had ever been landed.

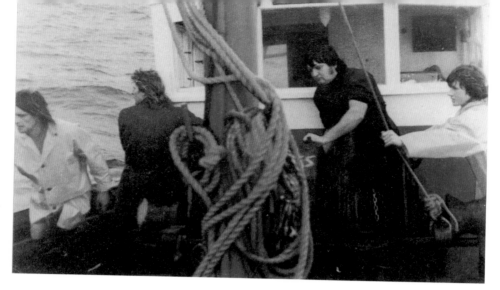

The crew pulling in the net aboard the Appledore-based, French-built boat *Jose Jacqueline*, BD 88, in the summer of 1978. The four on the winch are, left to right, Chris Sylvester, Skipper Tony Riley, Mate Dave Dinage and Stephen Sylvester (Birds Eye), eldest son of Chris. (*Felicity Sylvester*)

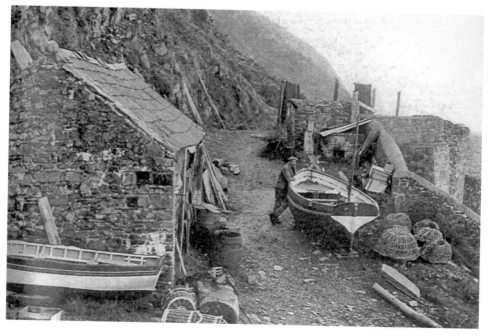

Two boats at Bucks Mills, just along the coast from Clovelly, another cliff-hanging hamlet. These boats were almost identical to the Clovelly picarooners, though slightly smaller, and had to be hauled up the roadway from the beach. An even smaller Bucks Mills ledge boat was used here to fish off the ledges that lie offshore, though only a couple of examples exist. In early times there was a quay here, which was subsequently destroyed by the sea. Note the lobster pots.

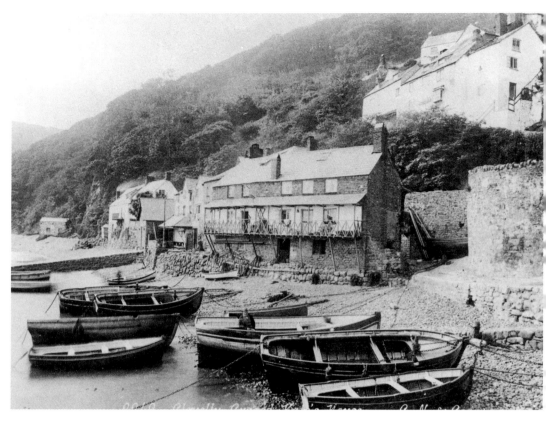

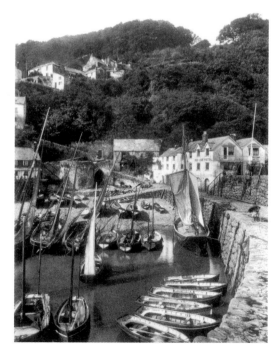

Crazy Kate's House at Clovelly. The story goes that Kate Lyall's husband was a fisherman who fished within sight of the house, watched by Kate from the upper window. One day he was overcome by a heavy squall and drowned. She became demented without him and eventually walked in to the sea, dressed in her wedding dress, to join her husband in a watery grave. The house is said to be the oldest in the village, dating from the eighteenth century.

Clovelly's harbour dates from the fourteenth century, and here in the late nineteenth century it is packed with craft of all sizes. Today, although much quieter, it is still home to several fishing boats, with the fishers coming from the village. The annual herring festival in November is a celebration of the silver darlings and their importance to the growth (and survival) of the village, and is well worth a visit.